DRAWING

A Sketch and Textbook

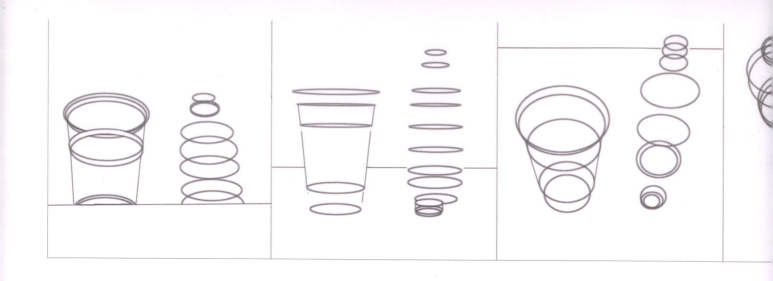

DRAWING

A Sketch and Textbook

Margaret Lazzari

Professor, *USC Roski School of Art and Design*

Dona Schlesier

Professor Emerita

Divine Word College

Douglas Schlesier

Professor Emeritus

Clarke University

New York | Oxford

OXFORD UNIVERSITY PRESS

Oxford University Press is a department of the University of Oxford.
It furthers the University'sobjective of excellence in research,
scholarship, and education by publishing worldwide.

Oxford New York
Auckland Cape Town Dar es Salaam Hong Kong Karachi
Kuala Lumpur Madrid Melbourne Mexico City Nairobi
New Delhi Shanghai Taipei Toronto

With offices in
Argentina Austria Brazil Chile Czech Republic France Greece
Guatemala Hungary Italy Japan Poland Portugal Singapore
South Korea Switzerland Thailand Turkey Ukraine Vietnam

For titles covered by Section 112 of the US Higher Education
Opportunity Act, please visit www.oup.com/us/he for the
latest information about pricing and alternate formats.

Published by Oxford University Press
198 Madison Avenue, New York, NY 10016
http://www.oup.com

Oxford is a registered trademark of Oxford University Press.

Library of Congress Cataloging-in-Publication Data
Lazzari, Margaret R.
 Drawing : a sketch and textbook / Margaret Lazzari, Professor, Gayle Garner Roski
School of Fine Arts, University of Southern California; Dona Schlesier, Professor Emerita,
Divine Word College (Epworth, Ia); Douglas Schlesier, Professor Emeritus, Clarke University
(Dubuque, Ia). — First edition.
 pages cm
 Includes index.
 ISBN 978-0-19-936827-3 (alk. paper)
 1. Drawing—Technique. I. Title.
 NC730.L395 2014
 741.2--dc23
 2014003482

Printing number: 9 8 7 6 5 4 3 2 1

Printed in China
on acid-free paper

To all those who love to draw

Draw here. Make this book your own.

CONTENTS

PART III: THE CREATIVE PROCESS

INTRODUCTION

Welcome to something new. *DRAWING: A Text and Sketchbook* is two books in one, a sketchbook AND an instructional book. You will be able to draw, mark, doodle, think, dream, reject, experiment, and make personal notes right on the pages where you are reading about drawing. As you work through the exercises, this book will become your own personal journal of renderings and notes for you to use as you to evaluate your development and to think about future work.

You will be happy to know that this instructional sketchbook is different from a conventional drawing textbook in which every page is filled (often excessively) with verbiage and images, but with no place to draw. It is also not a conventional blank sketchbook, whose emptiness can be uninspiring or even daunting. Rather, it is a combination of both formats that enables guidance, learning, and practice. Enhancing this combination is an even balance among the art reproductions, student works, diagrams, instructional text, and drawing spaces. Overall, it is a synthesis of both study and studio activities for a stimulating, thought provoking and meaningful learning experience in the art of drawing.

Here is a brief outline of what is covered inside:

Part I THE BASICS:
• Drawing materials and surfaces
• Methods for drawing from observation

Part II THE ELEMENTS OF DRAWING:
• The different kinds of lines, values, and textures you can draw, and how you can vary them to add meaning to your drawing
• Color in drawing
• Space in drawing

Part III THE CREATIVE PROCESS:
• Developing to your own visual vocabulary and personal expression
• Pulling all things together in your compositions
• Developing an analytical and critical eye

Throughout the book are F.Y.I. boxes, which suggest artists and artworks related to the techniques discussed in each chapter. Use the Internet on your Smartphones and laptops to research these artists for more ideas about artwork that you might make. The emphasis is on contemporary artists, but there are also many historical references.

Also, the book contains 🎥 icons that point you to online videos on drawing techniques or media. Better than thousands of words, the videos show you ways to draw from observation, measure while you draw, apply fixative properly, work with perspective, and much more.

We hope that the drawings and research you do in this book will be a treasury of ideas for future drawings. We cannot imagine any better end for this book than for each page to be filled with drawings and sketches and stuffed with images that you find or print out and make notes about. By the time you finish, the final book should look used and should increase in its original thickness.

Always keep sketching after you fill this sketchbook! After you fill this one, start another on your own. Sketching is a record of your thoughts, ideas, and observations for all your life.

USING THIS BOOK

This book contains concise instructions and quick references on drawing. Please feel free to use your Smartphone, computer, or any other digital device that may help you to access those references. Use the diagrams and examples for inspiration.

Ideally, you are also taking a drawing class or working in a drawing group at the same time. This sketchbook supplements that other instruction, both reviewing and expanding on that information. Most importantly, this book helps you take solid, basic drawing instruction to a higher and more personal artistic level.

DRAWING THROUGHOUT YOUR LIFE

We believe that learning to draw is a valuable asset and can serve you in life in many ways:

• Drawing can be a means for you to create beautiful or meaningful images.
• It is a way for you to express your innermost feelings.

- Drawing is a thinking tool. It helps with analysis and planning. Sketching out things you want to make. Make diagrams so you can understand physical relationships or cause-and-effect relationships. You will be able to see things more clearly.
- Drawing helps communicate ideas to others. Often a sketch on a napkin explains things to others much more clearly than thousands of words.

So we urge you to draw always. Watch your skills increase. See how helpful it is in your life. And most importantly . . . Enjoy!

ACKNOWLEDGMENTS

We wish to thank Oxford University Press both for their enthusiastic acceptance of our unique concept of our book, and their effort to bring it to press. We sincerely thank Richard Carlin and all of the staff for their support and hard work. And we are grateful to the artists, both student and professional, who graciously allowed us to use their work to illustrate the book; and to Jill Heitzman-Carlock, who as a beginning drawing student "tried out" the mockup of the text/sketchbook, and Lauren Evans, who also gave an early version of the book a "test run." It is from their efforts we were able to see that this approach would be indeed successful.

Many, many thanks also to Cecelia Davidson, who assisted in developing the manuscript, compiling the art log, and helping make the entire project come together.

We also thank our families and friends who listened many times to our ideas as the project developed, and who gave good advice at every step of the way.

The authors truly appreciate all of you, because together we have created a new approach to the learning experience in drawing which combines a textbook and a sketchbook. Students will make it their own and have it in hand as they move forward in life.

The authors wish to acknowledge the following reviewers who commented on earlier versions of this manuscript. Their helpful insights were greatly appreciated in the creation of this text.

Sanita Jetton *University of South Alabama*
Carol Heft *Muhlenberg College*
Susan Urbanek *Palm Beach State College*
Chad Hines *Central Texas College*
Jennifer Hall *Colorado Technical University*
Diane Hoffman *Brown University*
Cheryl Gelover *Montgomery County CC*
Mercedes McDonald *College of the Canyons*
Vanesa Madrid *Riverside City College*
Rodrigo Benavides *St. Phillips College*

THE BASICS

MEDIA AND MATERIALS

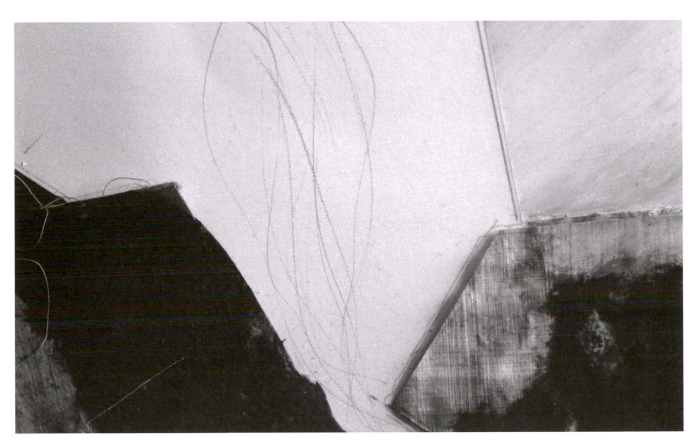

Figure 1.1
There is a wide range of possible drawing media. AUTHOR'S WORK, *The Elements That Be* (detail), 2006. Pencil, charcoal, thread, pastel and found materials on papyrus and paper.

MEDIA

DEFINITIONS: Drawing **media** are all the materials and tools that make marks on a surface; **grounds** are the surfaces on which drawing marks are made. To make a drawing, you need both medium and ground.

The drawing tool is your **medium**. **Media** consist of all the drawing supplies used by artists, illustrators, and designers. Even your eraser is a drawing tool, because it makes distinctive marks by subtraction. You can use the pens and markers in your desk, as well as art supplies.

Drawings can also be made with untraditional media like thread, a stick in a mud flat, or sand. Figure 1.1 was made with found materials and thread, in addition to charcoal, pencil, pastel and papyrus.

YOUR ART BOX

This list contains drawing tools and materials that are typical of an artist's box. These tools are very versatile, but your media does not have to be limited to these (as we saw with the soot drawing in Figure 1.1). Store these in a tool box from a hardware store or in a plastic box from an art supplier. This is the basic supply list for this book.

- Pencils: 2H, 6H, 2B, 6B, Ebony* and White
- Graphite stick
- Charcoals: vine and compressed**
- Soft pastels or colored chalks
- Oil pastels (a set of at least 24)
- Conté crayons: white, black, and earth tones
- Erasers: kneaded, pink, and plastic
- Pens: bamboo, quill, nib; also ball point, fountain, gel, and markers
- Brushes: Japanese and watercolor
- Inks: permanent black, sepia, white, and/or colored drawing inks

- Equipment:
 - Fixatives
 - Mat knife, craft knife or other cutting blade
 - Straight edges, rulers
 - Mechanical drafting tools (compass, templates etc.)
 - Artist tape (preferred) or masking tape
- Optional: 18″ × 24″ pad of acid-free paper; other papers in various weights and colors; set of 24 soft pastels; set of 12 pan watercolors; set of colored pencils

*Pencils come in different ranges of hardness. An H pencil makes a crisp light precise line while a B pencil makes a soft, dark, smudgy line. 6H is the hardest and 6B the softest. A #2 pencil is similar to a 2B pencil. An ebony pencil is a mixture of graphite and soft carbon, which gives very rich blacks that blend easily without using excessive pressure on the paper.

**Vine charcoal leaves very light marks that are easily erased. Compressed charcoal makes dense, black marks that cannot be completely erased.

Try out all your materials in the space below. Experiment.

Each drawing tool leaves a characteristic mark. The thin, regular mark of a ballpoint pen contrasts strongly with the rough crumbly mark of charcoal. Sometimes you will want to use controlled marks, sometimes smudgy marks, and everything in between. The beginning of any drawing is an experimental, searching process.

VIDEO 1: Watch a video demonstration showing creative ways you can use media and materials.

Figure 1.2
Examples of different media and the marks they make, and the way they look on white or black paper.

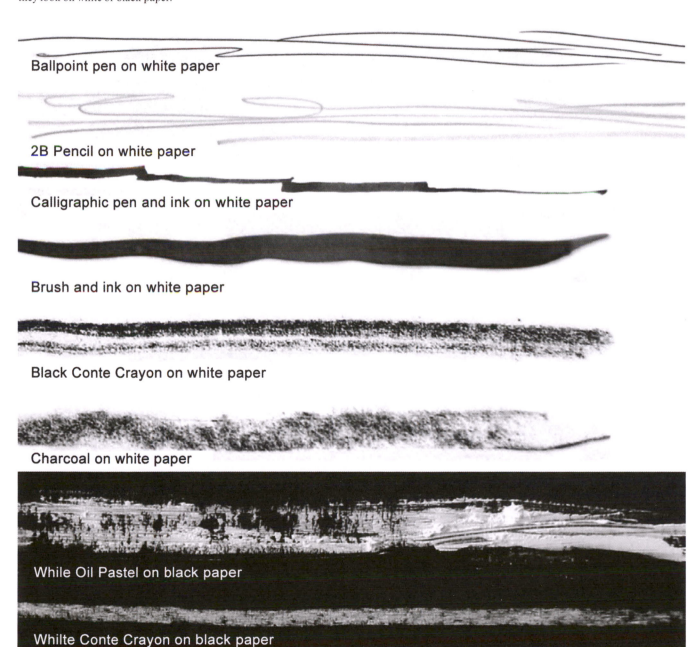

Ballpoint pen on white paper

2B Pencil on white paper

Calligraphic pen and ink on white paper

Brush and ink on white paper

Black Conte Crayon on white paper

Charcoal on white paper

While Oil Pastel on black paper

Whilte Conte Crayon on black paper

Experiment with your art supplies below. Use whatever is at hand.

Use white conté, white pencil, white-out pens, white oil pencils or any other white or light-colored media here.

==Do not "write" your sketches, "draw" them==. When writing, only your fingers move while your arm is fixed. When drawing on large paper, it helps to move your entire body, especially when you back up to check your progress. (Figure 1.3) Standing makes it easier to smudge, scrawl, jab, or sweep. Try holding the end of your pencil or charcoal with your fingertips.

==When you draw with the paper upright, you work on and see the drawing as the viewer will eventually see it, which is helpful.==

Figure 1.3
Writing and drawing postures.

F.Y.I.

Study videos of artists as they draw to watch their movements. Look for ones on Pablo Picasso or Julie Mehretu.

Prop up this sketchbook and drawing holding your pencil by the end. It may seem that you have less control, but that is only temporary. What you gain is much more variety in your marks.

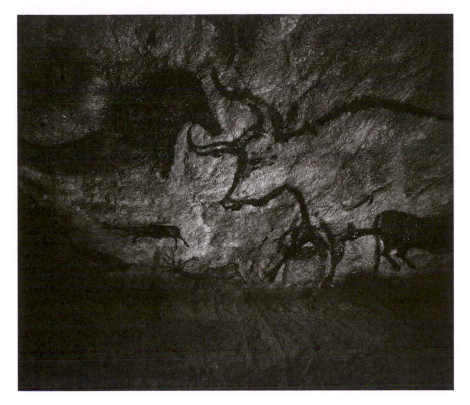

Figure 1.4
Drawing on rock. *Great Hall of Bulls* c. 15000–10,000 BCE. Reconstruction of an ancient rock painting, Lascaux, Dordogne, France.

GROUNDS

The surface upon which you draw is the **ground.** When you draw in this book, you are working on a paper ground. Beyond paper, though, a ground may be a wall, papyrus, stone, leather, fabric, wood, clay, glass, a plastic sheet, sheet metal, or almost any surface imaginable. Figure 1.4 shows drawings on cave walls, using the ancient media of burnt wood, dirt, and rock dust mixed with animal fat. Figure 1.5 shows a drawing done with white chalk with a dirt floor as a ground.

You can modify the ground. It can be made smoother or rougher, or it can be painted any color to create a **background.** Figure 1.2 shows examples of black and white backgrounds. Notice the contrast among media and different backgrounds.

F.Y.I.

Pablo Picasso and Georges Braque drew on collaged newspapers and menus. Martin Kippenberger did a series of drawings on hotel stationery. Henri de Toulouse-Lautrec drew on brown cardboard. Faith Ringgold made large painted story quilts. When you research these artists, you will see that the ground itself was important in the artwork and influenced its meaning.

Collect some scraps of fabric (lace, burlap, old clothes, etc.) and/or different kinds of paper (tissue paper, sandpaper, corrugated cardboard, wrapping paper, wallpaper, etc.). Attach them below and experiment with making marks in various media.

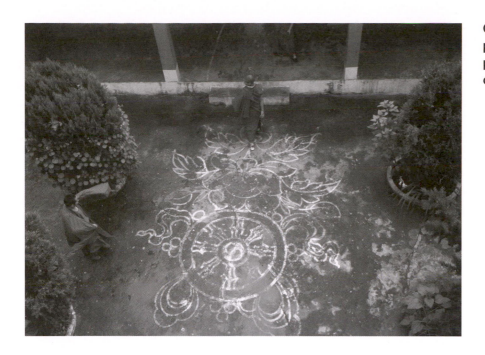

Choose one of the fabrics or paper types used on the previous page. Make a small drawing on that ground here.

Figure 1.5
Drawing on the dirt with chalk. *Tibetan Monks with Chalk Mandala,* August 1996, Dharamsala, India. An aerial view of Tibetan monks and a chalk drawing featuring a mandala.

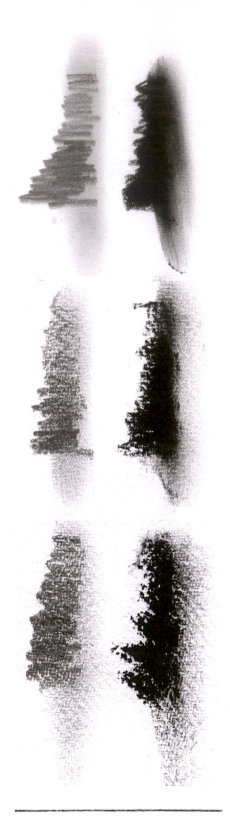

PAPER QUALITIES

Paper is the most common ground for drawing. Paper qualities vary in: (1) **tooth** (the smoothness or coarseness of the surface); (2) **weight** (the thickness or thinness of a sheet); (3) **content** (paper can be made from wood, from a variety of plants and from cloth); (4) **acidity**, which affects how much it yellows over time; and (5) **sizing**, which determines how absorbent it is.

Coarse-toothed paper generally results in textured marks and tones, while a smoother tooth results in crisper lines, as seen in Figure 1.6. The top sample is smooth, the bottom is very rough, while the middle one has a medium tooth. On each sample, quick marks were made and then smeared with a fingertip.

A 6B pencil was used on the left side of each, and compressed charcoal on the right. On smooth paper, you get precise marks and subtle tonal gradations, while marks on the textured paper have rough, coarse characteristics.

Figure 1.6
Drawing on rough or smooth paper.

The weight of the paper determines how much you can work it. Thicker paper holds up to both wet and dry media as well as vigorous erasing and smudging. Thinner paper is more fragile and breaks down with water or overworking.

It is also important to consider the content and acidity of paper. Paper with high rag (cloth) content is very strong and lasts well over time. Paper of 100% rag is a high-quality non-acid paper. There are also many good papers made of wood pulp or plant material that are acid-free. However, wood-pulp paper with high acidity yellows and deteriorates relatively quickly. Newsprint is a high-acid paper and is therefore only appropriate for drawings you do not intend to keep. If you want your drawing to hold up well over time, use acid-free paper and store it away from dirt or moisture.

Many artists use newsprint for warm-up drawings, but sometimes those quick drawings can be very nice, so consider doing your warm-up drawings on the back sides of good paper.

Sizing is an additive used in the paper-making process that affects the absorbency of the paper. Heavily sized paper resists liquid media, so that inks remain on the surface, resulting in clean lines rather than being sucked into the paper. The difference is clear when you draw with a marker on printer paper (sized paper) versus paper towels (unsized paper).

Swap and trade to get six different paper samples. Make notes about their surface, weight, content, acidity, and sizing. Draw on them with various media. Which ones appeal to you?

Continue with six paper samples, with different surface, weight, content, acidity, and sizing.

DRAWING FROM OBSERVATION

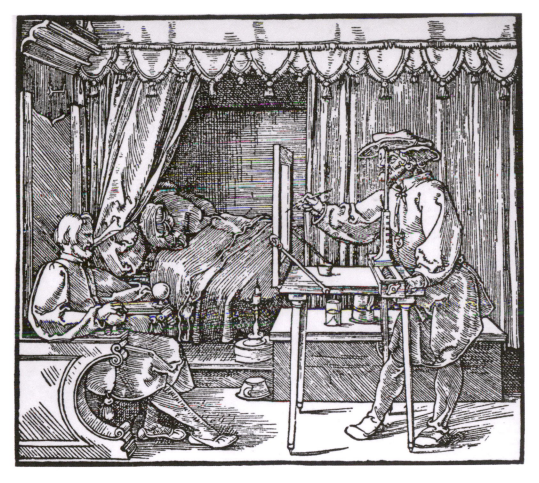

Figure 2.1
Artists have long used devices to aid in drawing from observation. ALBRECHT DÜRER.
An artist drawing a seated man on to a pane of glass through a sightvane. Woodcut from
Underweysung der Messung (Art of Measurement), Nuremberg, 1525.

The ability to draw from observation and to have your drawing resemble what you see is an important skill.

Drawing is different from seeing in real life. Your actual vision has no edges, has sharp and blurry areas, and is fluid because you are constantly moving (and often, your subject is moving too!). In contrast, a drawing is fixed and still, with clear edges (Figure 2.1), and isolates an image in time. This chapter will introduce you to tools and processes for this type of drawing.

FRAMES

When drawing from observation, first decide what to include and exclude. A frame helps you to focus on that (Figure 2.2). Extend your arm fully with your elbow locked, so that the frame remains at a constant distance from your eye. Hold the frame absolutely vertically, at a 90-degree angle to your arm. Close one eye and look through the frame.

Figure 2.2
At left is a still life set up in a room; at right, the frame has isolated one view that you might want to draw.

Figure 2.3a
Fixed frame.

Use stiff paper or cardboard to make either a fixed frame (Figure 2.3a) or an adjustable frame (Figure 2.3b). Either one works well, but the adjustable frame is more versatile and can give you wide rectangles for landscape drawings or tall rectangles for figurative work.

1. Fixed Frame:
 Cut away a rectangular center opening out of a large piece of stiff paper. The opening should be proportional to the size of paper you usually use. For example, a 3″ × 4″ opening is proportional to drawing paper that is 9″ × 12″ or 18″ × 24″. Make sure to leave a 3″ border around the entire opening.

2. Adjustable Frame:
 From a large piece of stiff paper, cut two L-shapes, at least 3″ wide and each leg 8″ long. Using two paperclips or binder clips, clamp the L-shapes so that the center opening is proportional to your drawing.

Figure 2.3b
Adjustable frame.

The frame helps you to isolate and identify possible views when you move the frame around and move yourself to new positions: left, right, closer, or farther away. Remember, always keep your arm fully extended and elbow locked as you move around.

 VIDEO 2: Using Frames While Drawing

THUMBNAIL SKETCHES

VIDEO 3: Thumbnail Sketches

The frame gives you a lot of options, but how do you evaluate the various views? Which will be the best? Many artists use small, minimal sketches called **thumbnails** to experiment with different angles and views before committing themselves to a larger drawing (Figure 2.4). Thumbnails act as visual short-hand with minimal details to show the key elements of a polished drawing. Thumbnails are your friends: They are enormously helpful in planning a work of art.

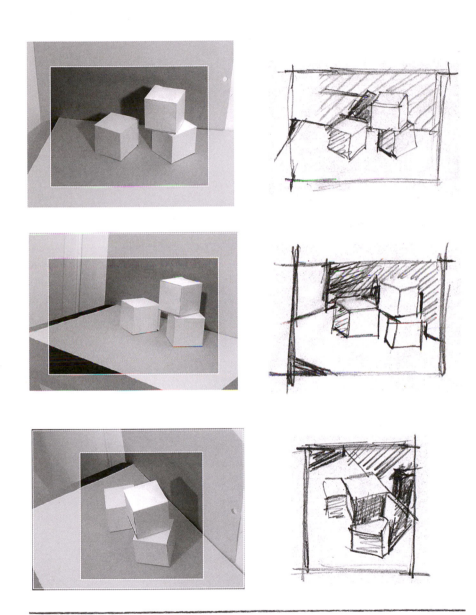

Figure 2.4
Examples of thumbnail sketches, which often are as small as an inch in one dimension.

Make some thumbnail sketches of a set of objects seen from different viewpoints.

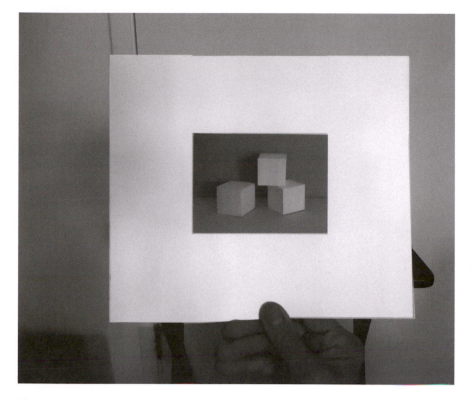

Figure 2.5
Detail of Figure 2.2.

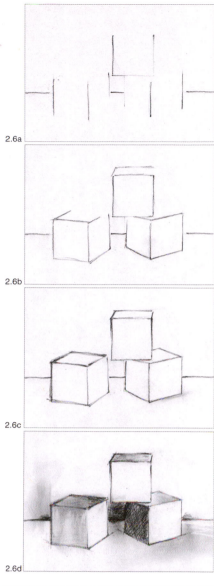

2.6a

2.6b

2.6c

2.6d

Figure 2.6
2.6a at top, b, c, and d at bottom. Building a drawing that corresponds to your selection in the frame.

The drawing starts with your eye and your choices. Choose the thumbnail sketch you like best. Return to that position and hold the frame as you did before (Figure 2.5). Set up your paper, the size of which must be proportional to the inside opening of the frame.

Draw the most important edges first (Figure 2.6a). Start with the back edge of the table top and the vertical lines of the boxes. Place these lines on the paper exactly as they appear to you within the inner frame. Make sure everything fits on your paper. Make changes now, if needed.

Draw the rest of the lines relative to your first lines (Figure 2.6b, c, d). Each line you add builds on the initial marks you drew.

Set up some boxes on a table. Use a frame to select what you want to draw. Draw a proportionally sized rectangle on this page, and do your drawing inside this shape.

Real life is often much more full of visual clutter and activity than what you experience when drawing three boxes on a table. The frame becomes more helpful as your subject matter becomes more complex.

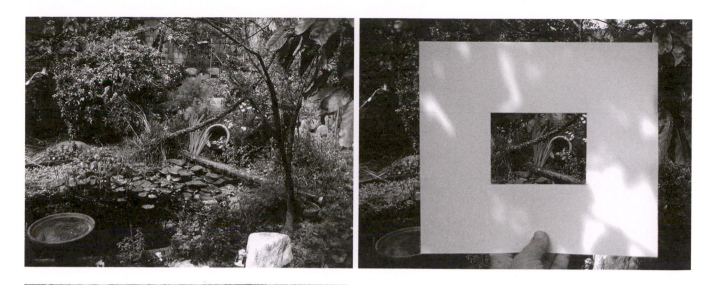

Figure 2.7
Using a frame to select your composition in a complex scene.

Use your frame to make a few thumbnails of busy cityscapes or landscapes.

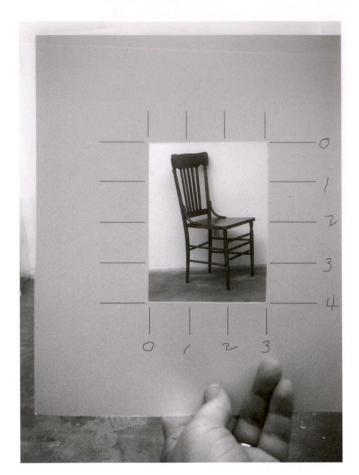

Mark the opening of the frame in inch or half-inch increments. This will help you place shapes on your drawing more accurately. In Figure 2.8, the incremental marks help you better judge where, for example, the seat of the chair should be placed in your drawing. Is the seat at the middle of the frame, or is it higher or lower? Closer to the right edge or left?

You can determine the angles of edges on your object by comparing them with the horizontal and vertical edges of the frame opening.

You can determine how long one part is compared to another with the ruler marks on the frame.

F.Y.I.

Artists have used various framing devices when drawing. Jan Vermeer used a camera obscura, which is a box that can project an image onto a wall or piece of paper through a small lens. Other artist like Albrecht Durer and Jan van Eyck drew on a sheet of glass while looking through an eye hole at the end of a stick, so that their eyes did not move relative to the drawings (Figure 2.1).

Figure 2.8
Using the ruler marks to determine placement more accurately, and to determine the relative lengths of features within an object.

Mark incremental lines on the inside of your frame and make a drawing.

MEASURING WITH A PENCIL

Another helpful drawing method is to make measurements using a pencil and the edges of your paper as guides.

When drawing complex forms, you often have to measure the relative length of one part compared to another part (Figure 2.9). To do so,

- Hold your pencil at arm's length, with your elbow straight and locked (just as you do with the frame!).
- Close one eye.
- Use your thumb or finger to mark off lengths; in Figure 2.9, you can see that the height of the front leg is about half the height of the entire chair.
- Keep that ratio of chair height to chair leg when you make your drawing of the chair.

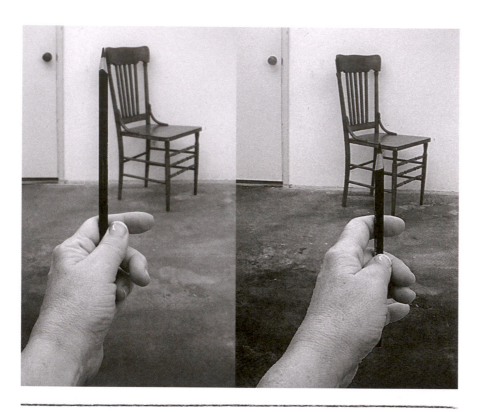

Figure 2.9
Measuring with a pencil while drawing from observation.

To determine the direction of objects that you are drawing from observation, do the following.

- With your elbow locked and one eye closed, hold up your pencil at an angle that mimics what you are observing, as in the chair seat in Figure 2.10.
- Note the angle of the pencil. One helpful trick is to imagine the pencil as a clock hand. Toward which number is it pointing?

- Then, when drawing that shape, use the edges of your paper as horizontal and vertical guides, and place your marks on the page at the same angle and proportional length that you observed (Figure 2.10).

 VIDEO 4: Measuring with a Pencil

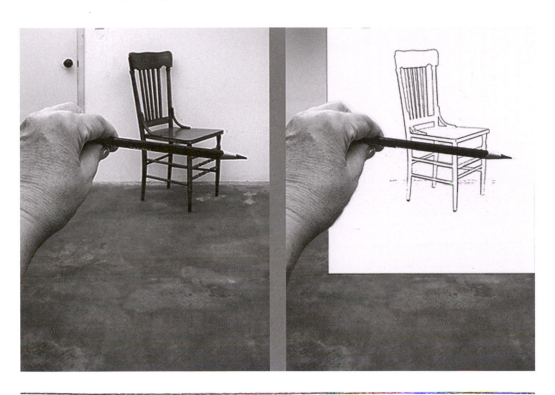

Figure 2.10
Determining direction. Note the direction of an observed form (here, a chair seat), relative to true horizontal or vertical. Use the edges of your paper as horizontal and vertical guides, and draw the leg relative to those edges.

Use the frame and pencil measurement to sketch some objects or the inside of a room.

LIGHT UPON OBJECTS

One important thing about drawing from observation is to draw the effect of light upon objects. Light falls on structures and casts shadows in a systematic, logical way. We want you to be aware of this now, but we will also deal with this in greater detail in Chapter 5.

When there is only one light source, you can observe the following phenomena (Figure 2.11):

- The light source consistently lights the sides of objects that face the same direction.
- Shadows are consistently cast in the opposite direction from the light source.

 VIDEO 5: How Light Affects Shadows

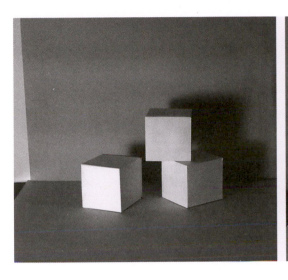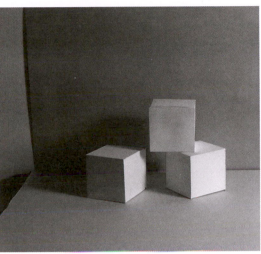

Figure 2.11
These two photographs are the same arrangement of boxes, but the location of the light source has changed. Study how light falls on objects and creates cast shadows.

Draw boxes with one light shining brightly on them. Use your pencil to measure the direction and length of shadows, just as you do to measure the direction and length of edges of objects.

THE ELEMENTS OF DRAWING

LINES

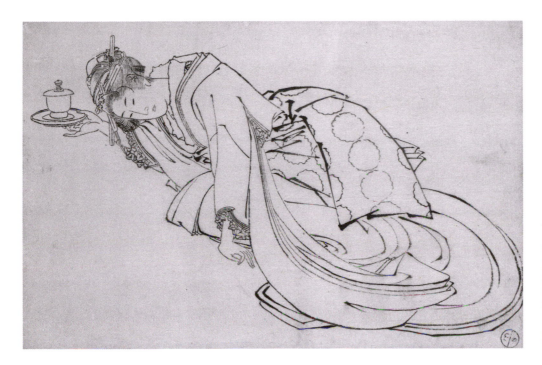

Figure 3.1
There is an incredible variety possible with line as seen in the image above. *A Courtesan Offering a Cup.* Japanese, 18th–19th century. Pen and ink on paper. School of Musée des Beaux-Artes, Angers, France.

DEFINITION: In math, a line is a moving point having length and no width. In art, a line is a mark or stroke that is long in comparison to its width.

MAKING LINES

Lines are fundamental in drawing and visual language, just as letters make words in written language.

You can make lines with almost any tool in your art box, as we saw in the first chapter, Figure 1.2. In this chapter in Figure 3.1, you can see many kinds of lines made just with pen and ink, ranging from bold, sweeping, choppy, ultra-fine, and so on. In addition, you can modify tools or create new tools that will give you great variety in the lines you draw (Figure 3.2).

 VIDEO 6: Line and Mark Making

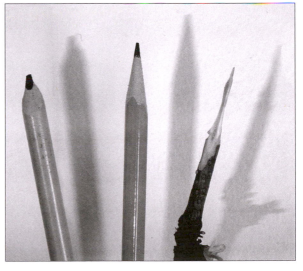

Figure 3.2
Modify ordinary drawing tools for more kinds of lines. For example, carve a chisel point on a pencil. A twig can be carved and dipped in ink to give an amazing variety of lines.

BASIC ATTRIBUTES OF LINES

Of the many qualities of line, the three central attributes of lines are (1) whether the line itself is **actual** or **implied**, (2) **direction**, and (3) **weight.**

Actual lines are made with a medium on a ground and physically exist. The drawing that opens this chapter, Figure 3.1, contains actual lines. **Implied lines** are broken, but our eyes connect the parts so that they seem quite real visually. Figure 3.3 compares actual and implied lines. Implied lines can seem playful, tentative, or suggestive (Figure 3.4).

Figure 3.3
Actual (left) and implied (right) lines.

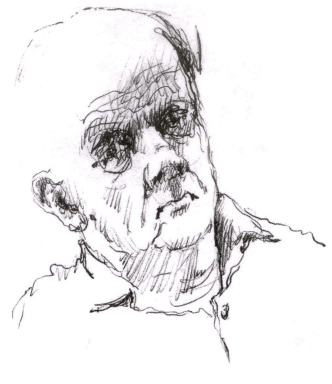

Figure 3.4
Note the implied line defining the top of the head using dots, dashes, and broken lines, and the way these lines contribute to a softened and aged feel. AUTHOR WORK, *Head Sketch.* Ballpoint pen on paper, 8 ½ × 11 inches.

Sketch using actual lines and implied lines.

Lines have **direction**: vertical, horizontal, and/or a diagonal (Figure 3.5). Line direction can be a focus in a drawing and can give it meaning as well. For example, vertical lines often allude to ideas of growth or aspiration, while horizontal lines are often related to rest, peace, or expansive space (Figure 3.6). Diagonal lines suggest change, energy, or movement (Figure 3.7).

Figure 3.5
Vertical, horizontal, and diagonal lines.

Figure 3.6
Horizontal lines predominate at the top, and contrast with the verticals and diagonals at the bottom. SUSAN BRENNER, Topographies 08008, 2008. Archival inkjet print on Somerset paper, 30 × 22 inches, edition of 3.

F.Y.I.

Research the drawings of Wassily Kandinsky to see examples of dramatic use of line direction. Also, find examples from contemporary animation or comic books with attention-grabbing line direction.

Figure 3.7
Diagonal lines predominate here, adding a sense of dynamism and power. DRAWING BY AUTHOR. Ballpoint pen on paper, 7½ × 6 inches.

Sketch bare branches of trees, machine parts, or other objects with strong directional qualities.

Weight refers to the thinness or thickness of lines (Figure 3.8). Line weight is used for variety and emphasis, like instruments in the string section of an orchestra: violin, viola, cello, and bass.

F.Y.I.

The drawings of Käthe Kollwitz are examples of work with varied line weight. Her drawings and prints are often intensely emotional. Analyze how the line quality helps to communicate emotion.

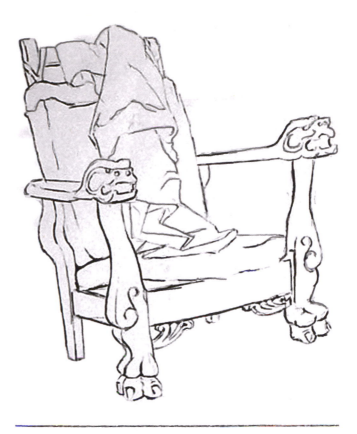

Figure 3.8
The heavier weight of lines in the chair attract attention, while the cloth is de-emphasized. DRAWING BY AUTHOR AS A STUDENT, *Lion Chair.* Pencil on paper, 8 ½ × 11 inches.

Experiment with weighted line sketches.

LINES THAT DESCRIBE FORM

Lines can be used to define forms in the following ways (Figure 3.9):

- An **outline** is a line of even thickness that exactly follows the outer edges of an object.
- **Contour lines** define the edges of a form and major divisions within it. Unlike the outline, contour lines vary in weight and describe spatial relationships, volumes, and significant inner areas as well as an overall shape.
- **Cross-contour lines** define the surface of a volume. With careful observation, the artist draws lines across the surface of the object, much like a topographic map (Figure 3.10).

VIDEO 7: Drawing Outlines, Contours and Cross-contour Lines to Describe Form

F.Y.I.

- The Nazca Lines of Peru are huge, ancient outline drawings scraped directly into the earth.
- Check out the use of contour lines in the work of Ida Applebroog, Gaston Lachaise, and Juan Gris.
- Research the beautiful outline and contour drawings from the Safavid period in Persia.
- Look at Henry Moore's sketches for his sculpture studies and his underground drawings from World War II. These contain great examples of cross-contour lines.

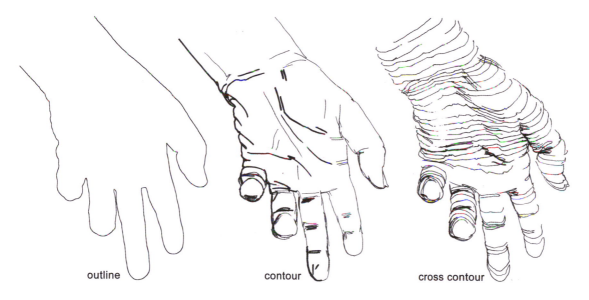

outline contour cross contour

Figure 3.9
Types of lines that define forms.

Experiment with outline, contour, and cross-contour lines here.

Figure 3.10
Note the cross-contour lines in the sheets, the jeans, and across the
chin and neck of the young man, in contrast to the outer edges. The
hundreds of lines also indicate the emotional complexity of the subject.
KRISTIN CALABRESE, illustration for *Shipwrecks and Other
Drownings* by Stewart Lindh, 2006. Pencil on paper, 8.5 × 11 inches.

Sketch your hand holding something like a cloth, using outline, contour, and cross-contour lines.

In addition to outline, contour, and cross-contour drawings, **gesture drawings** also describe form, but from the inside out, in a way that is meant to capture the essence of a form (Figure 3.11 and 3.12). A gesture drawing is a quick sketch that enables the artist to observe and draw almost simultaneously.

VIDEO 8: Making Gesture Drawings

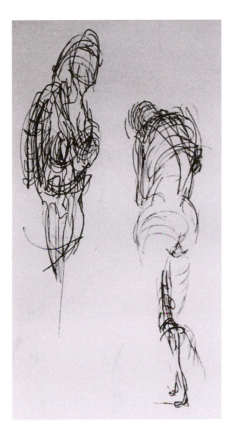

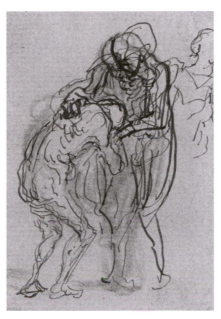

Figure 3.12
The lines in this gesture drawing are very active and suggest movement. HONORÉ DAUMIER, *The Prodigal Son.* Pen and black ink with wash on laid paper, 3.5 × 2.5 inches. National Gallery of Art, Rosenwald Collection.

Figure 3.11
A gesture drawing is an intense "dance" combining looking and sketching, to capture the internal spirit and basic form of your subject. DRAWING BY AUTHOR AS A STUDENT. Pen and ink on paper, 10 × 6 inches.

In the space below, do at least 10 gesture drawings of children in a playground, capturing the spirit of the individuals through their pose: playful, happy, uncertain, tired, pushy, content, fearless, shy, etc. Each gesture drawing should take no more than one minute.

EXPRESSIVE QUALITIES OF LINE

In gesture drawings, you want to convey attitude and emotion. Again, you can accomplish this primarily through the pose. But you can also exaggerate the basic attributes of line (actual/implied, weight, direction) to make the lines themselves carry emotional quality.

For example, compare the sagging, droopy forms of the gesture in Figure 3.11, rendered with very rounded lines, to the angular, energetic lines used to render the two girls in Figure 3.13. The Daumier sketch in Figure 3.14 conveys yet another emotional quality.

Thus, emotional quality can be carried in the quality of the line itself. See also Figure 3.14.

F.Y.I.

Look at the work of Sol LeWitt, who was known for large wall drawings with different kinds of lines, made according to guidelines set by the artist. Another artist to research is Cy Twombly, whose drawings often contain flowing lines.

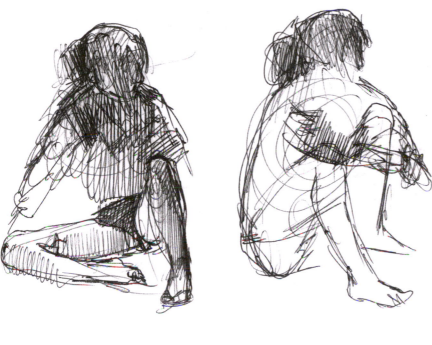

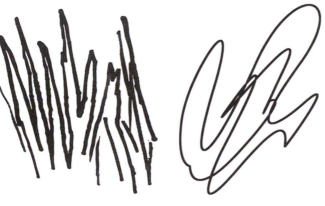

Figure 3.13
The angular line quality gives these sketches an energetic and attentive feeling. AUTHOR WORK, Two sketches of a girl, 2009. Ballpoint pen on paper, 4 × 6 inches.

Figure 3.14
Observe the difference in emotional quality between the jagged and the flowing lines.

Figure 3.15 shows an example of extreme variation in line weight, creating an expressive quality of a heavily lined face and a slumping body. Also, the choice of medium contributes important characteristics to a drawing—ink and brush lines are very different from those of a ballpoint pen (Figure 3.13)

F.Y.I.
Explore the expressive drawings of Honoré Daumier and Rico LeBrun, and note the differences in the weights of lines that they use.

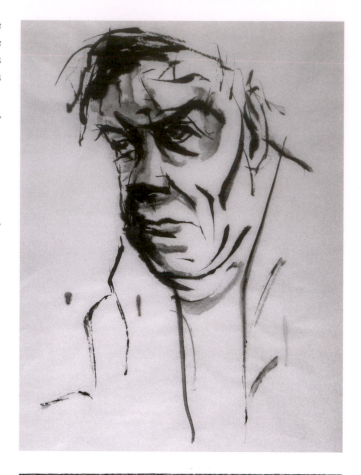

Figure 3.15
The expressive lines of this portrait were created with ink washes and a brush. CHRISTOPHER CHINN, *Old Man on the Street*, 2011. Ink on paper, 32 × 20.5 inches.

In Figure 3.15, the artist used a specific line quality to express an emotional reaction to homelessness and homeless people. Choose a subject that resonates with you emotionally. Draw it with a medium with a line quality that will enhance the expression of your emotional response to your subject.

In Figure 3.16, the artist used extreme variation in line direction and made heavy use of implied lines to create a drawing with a whimsical, absurdist quality. His lines were meandering and broken, and yet describe cross-contours.

F.Y.I.

Look up artists with distinct line qualities in their works. Paul Klee's drawings often have lively, bending lines. Research a collection of contemporary or historical comics, and note the line variations in examples such as *In the Bleachers*, *Lio*, *La Cucaracha*, and *Dick Tracy*, among others. Look at your favorites, also.

Figure 3.16
Meandering lines may have a humorous quality. PHILIP GUSTON, Untitled. 1980. Ink on paper, 18 ⅞ × 26 ⅜ inches. The Museum of Modern Art, New York.

Make some cartoon-like drawings using dramatic direction, actual versus implied lines, and expressive, meandering lines.

We have talked about extreme variations in line weight. But remember that lines with consistent weight or width also express ideas, mostly about control and precision and balance. Compare these two curvilinear drawings (Figures 3.17 and 3.18).

F.Y.I.

Investigate these artists and their distinctive line work:

- The drawings of Katsushika Hokusai contain calligraphic lines, as do those of Vincent Van Gogh and Henri Matisse.
- Contrast those works with Agnes Martin's large abstract drawings with highly controlled, straight lines, giving a clean, ethereal result.
- Keith Haring did patterned-based drawings of interlocking human figures, keeping the same line width throughout.

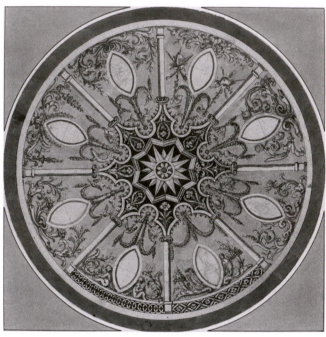

Figure 3.17
Lines with systematic variations in thickness and thinness are calligraphic, a term that refers to "beautiful writing" found in Chinese and Arabic scripts. While calligraphic, this drawing also has a sinister quality. EVONA LYNAE, *Predator's Fur*, 2009. Graphite, watercolor, red and blue watercolor pencil on paper, 60 × 40 inches.

Figure 3.18
The line quality in this drawing is very regular and controlled. French or Italian. Design for an Inlaid Circular Table Top. c. 1800. Pen and gray ink with gray and black washes over graphite on laid paper, 13 × 13 inches. National Gallery of Art, Ailsa Mellon Bruce Fund.

Mechanical lines (Figure 3.19) are not drawn free hand but are rendered with mechanical aids, as in geometrical and architectural drafting. Those tools, such as rulers, straight edges, compasses, and templates, can guide the hand in line making. Overall, a mechanical line is very regular and orderly, and it may appear more stable than a freely sketched line. This line characteristic contrasts with that of calligraphic lines.

F.Y.I.

Leonardo da Vinci's *Vitruvian Man* is a drawing of a man inscribed inside a circle and a square. The circle and square, drawn with clean mechanical lines, contrast with the more flowing, organic lines used to render the man. What do you think is the significance of that difference?

Figure 3.19
Comparing mechanical lines (left) and calligraphic lines (right).

Pick a subject and draw it with calligraphic lines. Draw it again with mechanical lines.

CRITICAL ANALYSIS

Choose a line drawing by an artist mentioned in one of the F.Y.I. boxes in this chapter. It must be a high quality printed reproduction, either a 4″ × 6″ illustration in a book, or an image from the Internet that is at least 1200 pixels wide.

Make a color hard copy of the image and paste it onto this page.

Use it to answer the following questions:

1. **First Glance.** Write at least two sentences about what strikes you visually about the drawing. What do you notice?

2. **Basic Line Attributes.** Describe the artist's use of actual/implied line, weight, and direction.

3. **Describe the expressive qualities of the line.**

Now return to one of your own line drawings. Change all of the attributes to their opposites. For example, if your drawing has very controlled lines, redo it with highly spontaneous, irregular lines. If it contained mostly actual lines, redo it with implied lines. For example, a drawing with all diagonal lines should be rendered using only horizontal and vertical lines.

VALUES

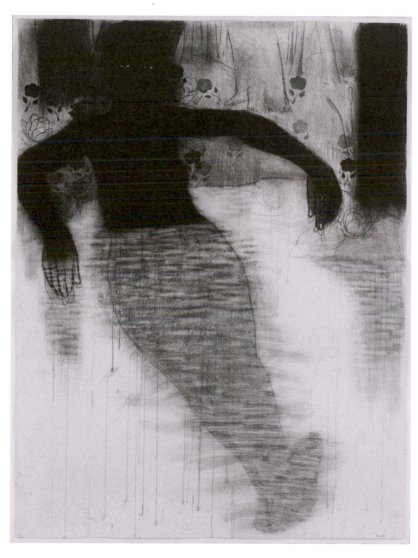

Figure 4.1
In a drawing, values are the white, gray, and black areas. The artist created a range of grays by building up and smudging soft black conté, and erased to create lighter gray marks. KERRY JAMES MARSHALL, *Study for Blue Water, Silver Moon*, 1991. Conté crayon and watercolor on paper, 49 ¾ × 38 ⅛ inches. The Museum of Modern Art, New York, NY.

DEFINITIONS: Values are different shades of gray, from black to white. Another term used for value is **tone**. However, tone usually describes a flat area of a value in a composition.

Values are areas of light and dark within a drawing, as distinguished from lines. Lights and dark areas add substance, weight, and atmosphere, beyond what is possible with lines, as seen in (Figure 4.1). However, we will build on what you have already learned about line in parts of this chapter.

A value scale (Figure 4.2) shows a gradation from black to white. The range could be infinite, but the scale below shows six tones of gray plus black and white. There is an equal amount of change between any two adjacent steps in the value scale. This is an **achromatic value scale**, which means without color.

Figure 4.2
The value scale in six gray tones plus black and white.

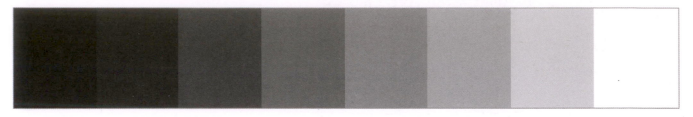

CREATING VALUES

You can create values in drawings by hatching, cross-hatching, layering, smudging, blending, and erasing (Figure 4.3).

In **hatching**, closely spaced parallel lines give the illusion of a tonal area. More lines create more extreme values. This effect occurs both when you use dark media on white paper and also white media on black paper. **Cross-hatching** has layers of hatching, with each layer at a different angle to the others. With hatching and cross-hatching, you can see the relationship between line and value.

Blending black and white is another way to create a value scale. In Figure 4.3, we see that black and white conté crayons were blended to create a range of grays.

Smudging is a smearing technique. You can use a cotton ball, Q-tip, tightly rolled paper, blending stumps, or your fingertip to smudge charcoal, soft pencil marks, or conté. You can smudge existing marks with an eraser as well, to lift out areas and create a range of light values, as we saw in Figure 4.1.

 VIDEO 9: Making a Reverse Value Drawing and Applying Fixative to Finished Drawings

Practice value gradations below, experimenting with black media, white media, and erasing.

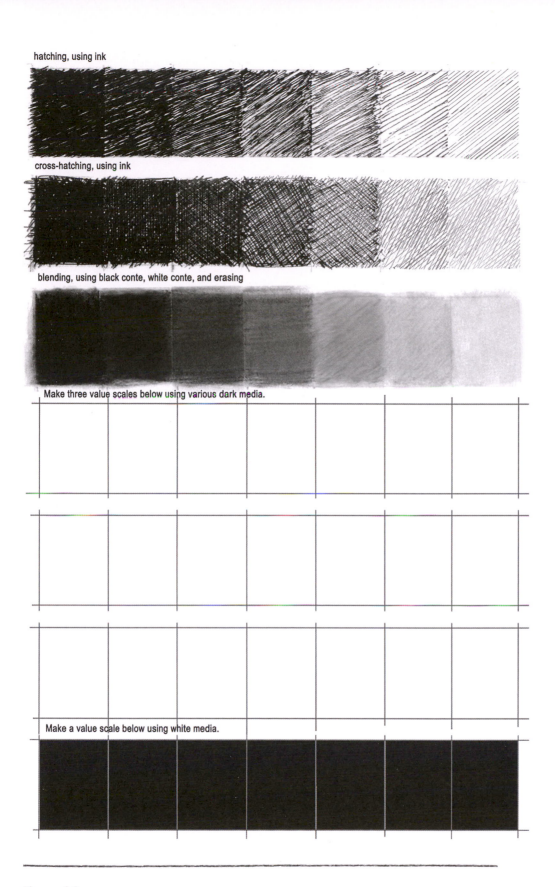

hatching, using ink

cross-hatching, using ink

blending, using black conte, white conte, and erasing

Make three value scales below using various dark media.

Make a value scale below using white media.

Figure 4.3
Creating a value scale by means of hatching, cross-hatching, and blending. In the blank boxes below, create more value scales by using smudging (pencil and charcoal), by diluting ink into gray washes, or by using black and white colored pencils.

Figure 4.4 Shows three self-portraits rendered with values created with pen and ink, ink wash, and charcoal.

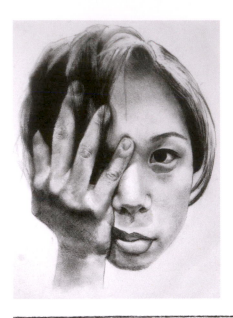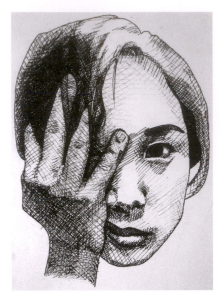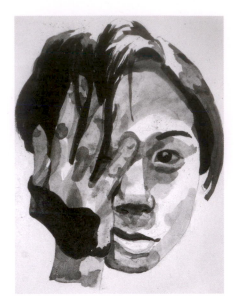

Figure 4.4
The artist used charcoal, cross-hatching with pen and ink, and ink washes to create values. JANICE SHANG, detail of three self-portraits from the *Twelve Self-Portraits* project. 2011. Each drawing, 16 × 20 inches. Details in charcoal, ink wash and pen/ink on paper. Student work.

F.Y.I.

Research traditional Chinese artists who use ink wash to create landscapes with low contrast in distant vistas and high contrast in foreground elements. Zhu Da and Ma Yuan are two such examples.

Sketch something simple like a shoe or a coffee cup, using values. Try out a variety of media.

GROUPING VALUES

The drawing in Figure 4.5 uses the full range of values, created by the carefully controlled application of pencil and charcoal. The lightest lights (the white of the paper) are maintained and the darkest darks are richly realized, plus a full range of grays can be seen in between. Notice how values are grouped; lighter areas are distinguished from darker areas. You can see this in the cloth. Where the light hits them, the folds are rendered as light grays. In the shadows, the folds are rendered as darker grays and blacks.

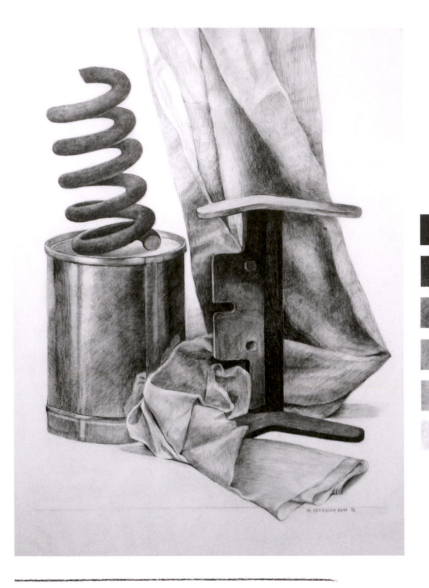

F.Y.I.

Leonardo da Vinci and Albrecht Dürer used hatching and cross-hatching in their drawings. Pierre-Paul Prud'hon used black and white conté to create delicate shadows on the human body. Look up their work.

Figure 4.5
There is a full range of values in this drawing, as seen by the value scale on the right, created with details from the drawing. SR. HELEN KERRIGAN BVM, Untitled Still Life, 1996. Pencil and charcoal on paper, 21 ¼ × 29 ¼ inches. Courtesy of Dona and Douglas Schlesier.

Do a still-life drawing in values. Light one area of the still life, and leave other areas in shadow.

DESCRIBING FORM WITH VALUES

Values can be used to describe form. *Chiaroscuro* is an Italian term that means "light dark." Artists use subtle transitions from light to dark to make a form seem rounded and three-dimensional. Chiaroscuro drawings use the full range from light to dark to create a sense of drama. The background is dark gray in value, so the lightest lights appear closest to the viewer, heightening the sense of the three-dimensionality. The term *chiaroscuro* is also used in cinematography to describe a similar visual effect in movies.

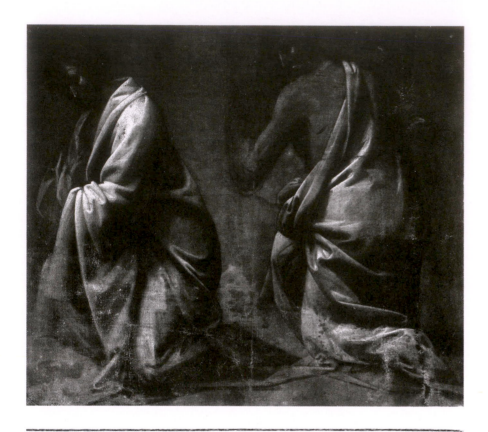

Figure 4.6
This drawing shows the technique of chiaroscuro, which the artist may have learned from Leonardo da Vinci. FRA BARTOLOMEO, Drapery studies of two kneeling figures, c. 1550. British Museum, London, UK.

F.Y.I.

Other notable artists known for chiaroscuro in drawing or painting are Caravaggio, Artemisia Gentileschi, Francisco de Zurburán, Georges de la Tour, and John Singer Sargent. Choose two and contrast their work.

In a sketch, use lights and darks to create the greatest sense of three-dimensionality that you possibly can in a form. Use the lightest lights for the focal point of your drawing.

CONTRAST

DEFINITION: CONTRAST is the degree of difference between the lightest and darkest parts of a drawing.

Contrast is one way to get expressiveness in your drawing. **Low-contrast** drawings are more understated or subtle, with a limited range of values (Figure 4.7). **High-contrast** drawings are dominated by strong blacks and whites, which add drama to a drawing (Figure 4.8).

Sometimes the very choice of medium can influence contrast. Using a hard-lead pencil, like 2H, results in low-contrast drawings, versus a soft, dark 6B pencil. Compressed charcoal drawings will almost always yield higher contrast than graphite drawings.

Reverse-value drawing is another way to create contrast. Rather than making dark marks on light paper, reverse-value drawings can be achieved by (1) an additive process, by building marks with a white medium on a dark paper, or (2) a reduction process, by erasing out areas that the artist darkened with charcoal to create lighter areas. Figure 4.8 is an example of a high-contrast drawing made by erasure.

Figure 4.7
This is an example of a low contrast drawing, with delicate gray tones dominating the composition. JOHN GLOVER, *An Oak Tree*, 1795. Pen and black ink with gray wash over graphite on wove paper, 5 × 6 ½ inches. National Gallery of Art.

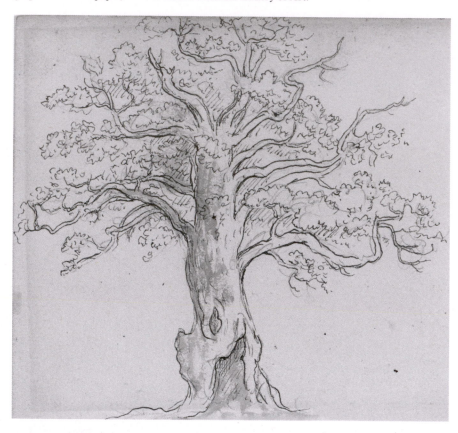

Figure 4.8
This is a high contrast drawing, with strong blacks and whites right next to each other. It is an example of a reverse value drawing. MOLLY HAUT, *The Three Skulls*, 2011. Charcoal on paper, 14 × 23 ½ inches. Student work.

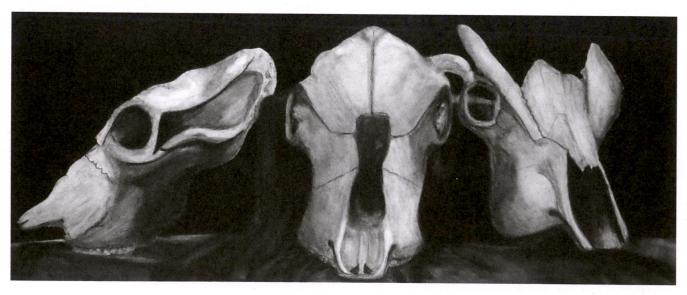

Use white media to make an additive value drawing in this gray area.

EXPRESSION THROUGH VALUES

Just as lines can appear jagged, flowing, meandering, and so on, values can also add to the expressive nature of a drawing. Three examples are given here, but other variations are possible.

Figure 4.9 is an example of a value drawing made with cross-hatched lines. On the facial features, the lines have been built up to create dark tones. The spiky, agitated quality of the lines, as well as the disarray in their arrangement, convey the personality of the subject and imply anger and distress.

In contrast, Figures 4.10 and 4.11 use values to express very different emotional qualities.

F.Y.I.

Look at the many ways these artists use value to express emotional dimensions: Georges Seurat, Charles White, Dox Thrash, Elizabeth Catlett, Georgia O'Keeffe, and Giambattista Tiepolo.

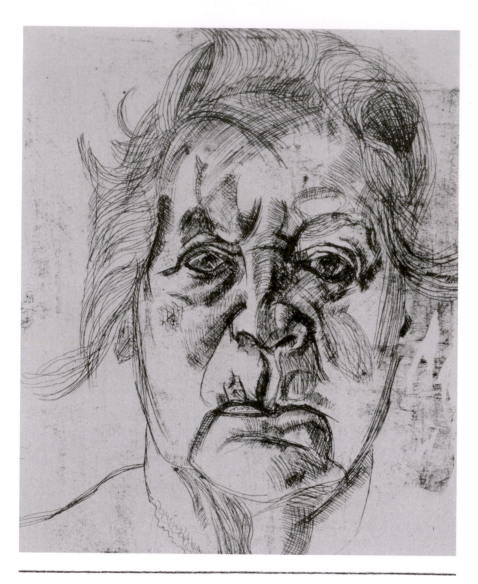

Figure 4.9
The quality of cross-hatching created both values and also an emotional response. LUCIEN FREUD, *The Painter's Mother*, 1982. Tate Gallery, London.

Draw a portrait of someone you know well, rendering it through values. Choose the medium that best expresses the emotional nature or personality of your subject. What qualities might be best expressed using charcoal? Using ink wash? Using pen and ink hatching? Be aware of the effects of low and high contrast.

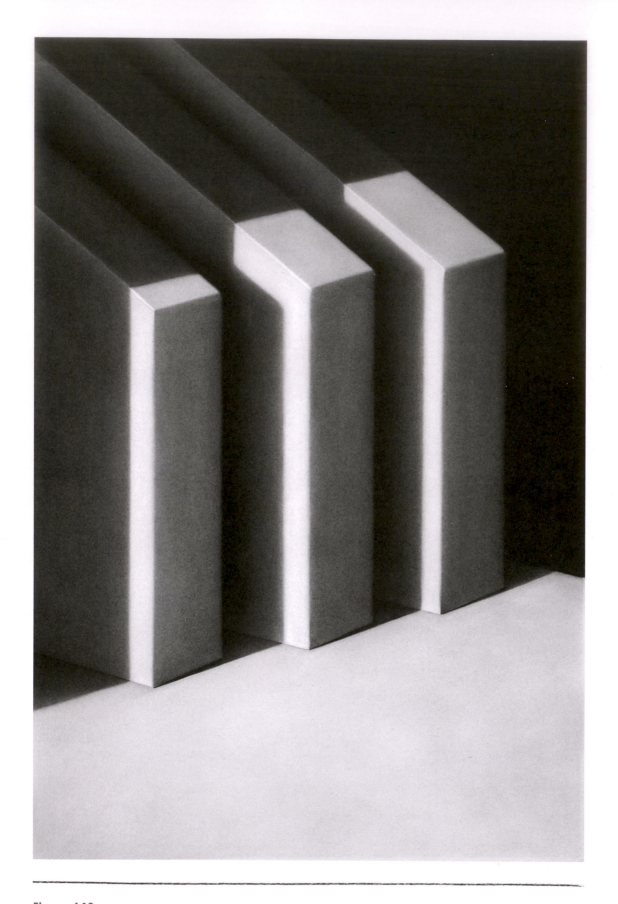

Figure 4.10
A drawing with a pristine rendering of values. RICHARD PARKER, *Three Walls*, 2012. Charcoal on paper, 44 × 30 inches.

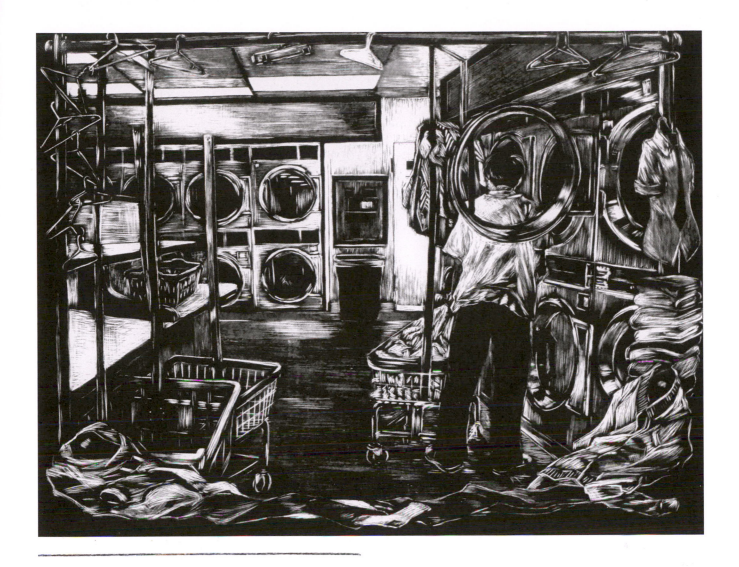

Figure 4.11
The chaos of a late-night laundry mat is captured in the frenetic way that the values are rendered. DANA YU, *Laundromat*, 2008. Scratchboard, 9.5 × 8 inches. Student work.

CRITICAL ANALYSIS: VALUE

Use Figures 4.10 and 4.11 for this exercise.

1. **First Glance.** Write at least two sentences about what strikes you visually about each drawing. What do you notice?

 Figure 4.10

 Figure 4.11

2. **Tonal Qualities.** Describe in detail the ways that each artist has created values. Do the tones appear smooth, jagged, or rough? Are the transitions gradual or abrupt? Consider the direction of the marks and the grouping of tones.

 Figure 4.10

 Figure 4.11

3. **What do you think the artist wanted to express through their handling of the values and medium? Were they successful?**

 Figure 4.10

 Figure 4.11

Sketch some place, person, or situation that causes strong feelings in you, and render it with values that express those feelings.

SHAPE AND VOLUME

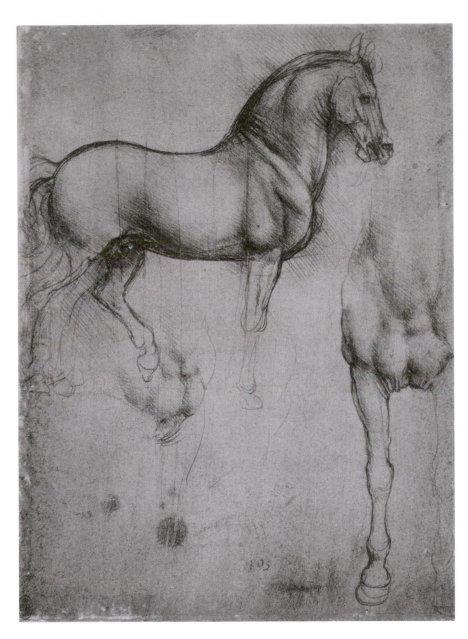

Figure 5.1
The volume of the horse is evident. The artist
has shown length, width and height of the
chest and neck in two sketches, and the
haunches in one. Once the basic volumes are
defined, shading and details are added later.
LEONARDO da VINCI, *Study of Horses*,
15th–early 16th century. Gabinetto dei
Disegni e delle Stampe, Uffizi, Florence, Italy.

Drawing shapes and volumes is the theme of this chapter.
Drawing is different from the physical world that exists in
three dimensions. Everything you draw really consist only
of marks on a two-dimensional surface. You can create the
illusion of three dimensions in drawing, and in this chapter,
we examine many ways of doing this. One classic example is
Figure 5.1, horse sketches that seem three-dimensional.

DEFINITIONS: Shape is a two-dimensional element. It is flat, with height and width, but it has no depth. Shapes can be either organic (irregular shapes) or geometric (a square or a circle, for example). **Volume** occupies space (height, width, and depth) in the real world.

In real life, an example of a shape would be a circle cut from a piece of paper. The corresponding volume would be a ball you hold in your hand. Figure 5.2 shows the relationship between drawing shapes and drawing volumes.

REVIEWING LINES THAT CREATE SHAPES AND VOLUMES

In Chapter 3, we showed how lines can be used to define form. Figure 5.3 relates how these lines describe shape and volume.

- *Outline* results in **shape**, because outlines exactly follow the outer edges of a form.
- *Contour Lines* define both the edges of a **shape** and simple internal **volumes.**
- *Cross Contour Lines* travel across and define the surface of a **volume**, thus describing three-dimensionality.

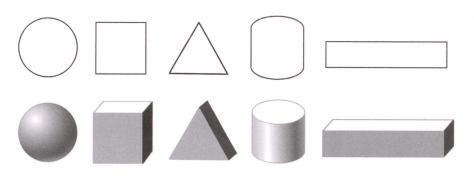

F.Y.I.

Look at the line drawings of Jean August Dominique Ingres, Henri Matisse, Pablo Picasso, David Hockney, and Suzanne Valadon. Focusing on their line drawings, analyze how they create shapes and volumes.

Figure 5.2
Shapes and corresponding volumes in drawing.

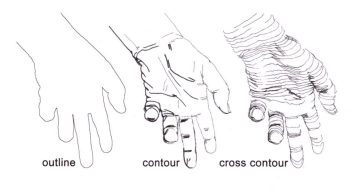

outline contour cross contour

Figure 5.3
A thumbnail of Figure 3.9, repeated here to show how lines can define either shape or volume, with outlines (left), contours (center), and cross-contours (right).

Put on one striped or plaid sock and leave the other foot bare. Do some line drawings of your feet.

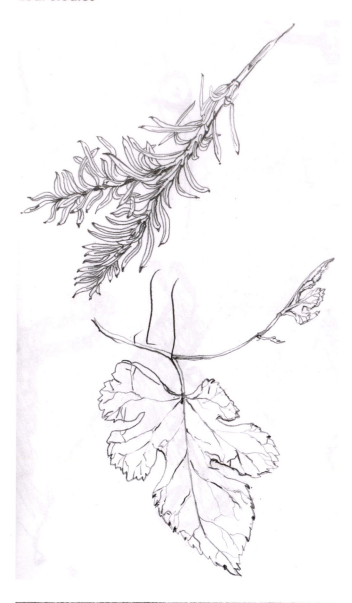

Figure 5.4
Contour line drawings cover the outlines of forms as well as major interior structures. AUTHOR AS STUDENT WORK. Pencil on paper.

USING VALUES TO CREATE SHAPES

Silhouettes are shapes that convey distinctive likenesses. Silhouettes have clear edges filled with a flat tone. They can be geometric or organic (Figure 5.5). Because the outlines are so distinctive in the first three below, we can imagine the three-dimensionality of what they represent. The last two, the circle over the rectangle, remain flat.

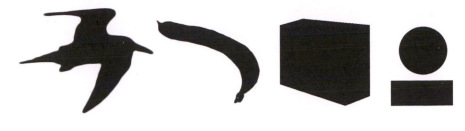

Figure 5.5
Silhouettes. Two are organic shapes (left) and three are geometric shapes (right).

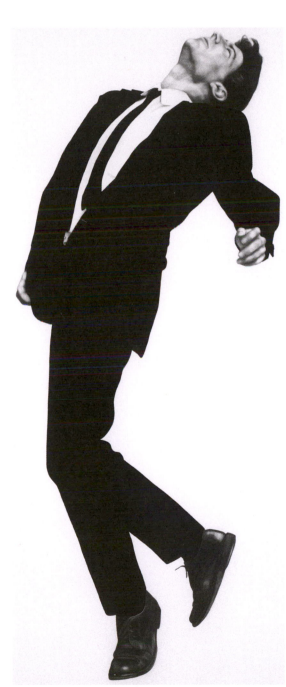

In Figure 5.6, the artist uses silhouette shapes to show the business suit. In contrast, the head, hands, and shoes are rendered three-dimensionally as volumes with shading, which we will cover next.

F.Y.I.

Research the art of Kara Walker, who uses large black silhouettes in her work.

Figure 5.6
Shapes predominate in this drawing of an off-balance businessman. ROBERT LONGO. *Men in the Cities Triptych (For the Pompidou).* 1980. Graphite pencil, charcoal, 96 × 60 inches. Musee National d'Art Moderne, Centre Georges Pompidou, Paris.

Cast some shadows on the walls, as you might have done when you were a kid, and sketch them. Observe carefully how dark the shadows are and the crispness or softness of their edges.

USING VALUE TO DEPICT VOLUME

Shading is the method used in drawing to create the illusion of volume with values.

DEFINITION: **Shading** is applying light and dark values in a drawing to depict how light falls on an object.

Your drawing paper is flat, and any mark you make on the paper exists on a two-dimensional plane. If you draw something that looks three-dimensional or solid, you have probably used shading to create an illusion of volume.

Rendering the effects of light on a form is vital to create this illusion. Look at the ball in Figure 5.7, drawn as if a single light were shining on it. The highlight, which is the brightest pinpoint of light, is white. Around the highlight is the next level of brightness. This lit surface is rendered as very light gray. Transitional mid-values lead around and down to the darkest surface on the ball. The bottom of the ball is not its darkest area, because light reflects from table surface onto it. The ball casts a full shadow onto the table top. The fuzzy edges are partially cast shadows.

 VIDEO 10: How Lighting and Shadow Describe Volume

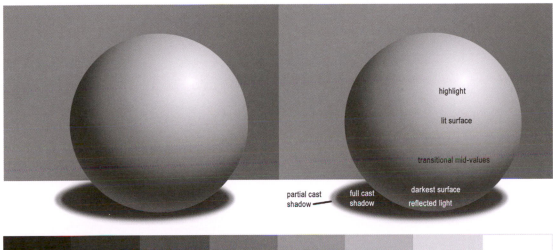

Figure 5.7
Compare the values on the balls with the value scale below them.

Do a drawing that includes a simple geometric object on a patterned surface, such as a tablecloth. You will be drawing shapes for the patterned surface and using shading to create volume for your geometric object. Pay attention to highlights, shaded surfaces, reflected light, fully cast shadows, and partially cast shadows.

Notice the transitions between one tone and the next when you are shading volumes (Figure 5.8). Very gradual transitions indicate smoothly curving surfaces. Quicker transitions indicate a surface that is moving in and out. Abrupt transitions create hard edges. Try to capture subtle qualities of edges and transitions in your drawing, as in Figure 5.8.

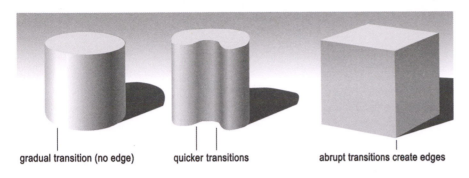

gradual transition (no edge) quicker transitions abrupt transitions create edges

Study all the different kinds of transitions that are found in Figure 5.9. The gradual and subtle transitions on the flat sides of the spoon ring contrast with the top edge. A variety of transitions make the curled decoration believable. Look also at the edges of cast shadows, the brightness of reflections, and how they are rendered.

Figure 5.8
Transition and edges on three objects, each lit by a single light source.

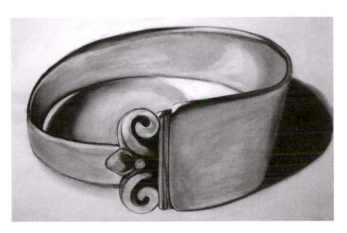

Figure 5.9
Subtle and abrupt value transitions, CHRISTINA ELLIS, *Grandmother's Spoon Ring*, 2011. Charcoal on paper, 16 × 20 inches. Student work.

Practice shading at least three differently shaped objects with a single light source.

Now look at the effects of multiple light sources on an object. In this case, we have selected an organic form (Figure 5.10). The tomato casts several shadows, and its top surface has many highlights. The darkest area is where many shadows overlap. The light sources are primarily from the left and the right. The front surface of the tomato receives no direct light, so it is darker than either the left or the right sides.

The rougher, less controlled marks give a more organic quality to the tomato drawing, versus the use of the computer for the sphere, which shows no touch of the human hand (Figure 5.11). These types of marks add an expressive quality to the drawings.

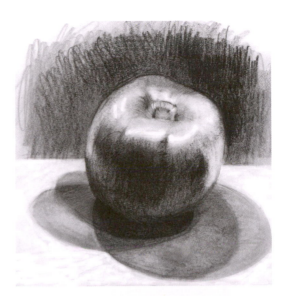

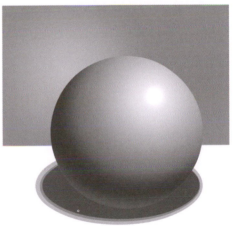

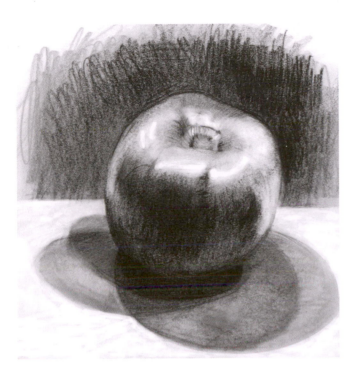

Figure 5.10
An organic form lit with multiple light sources.

Figure 5.11
Contrast the irregular shading on the organic tomato compared to the pristine surface of the geometric sphere.

At night, set up some simple organic forms on your desk, and illuminate them with two desk lamps. Replicate the way light falls on them, recording highlights, lit surfaces, transitional tones, darkest surfaces, reflections, fully cast shadows, overlapping shadows, and partially cast shadows.

DRAWING COMPLEX FORMS

Of course, most things you draw will be more complex than a ball or a box. Look closely and identify the largest, simplest shapes first, and their location in relation to each other (details will be added later). Then use simple volumes and cross contour lines to render the most fundamental defining features. Once the basics are in place, you add shading. As the drawing progresses, you will continue to refine the cross-contours, volumes, and shading until you have reached your desired level of detail.

A reminder: Review the instruction on Measurement in Chapter 2, especially Figures 2.8, 2.9, 2.10. This introduced you to using your pencil or a frame to help find proportions and properly place forms. This is very important when drawing complex forms. Figure 5.12 is a thumbnail image of Figure 2.10 that shows how to determine direction of forms when you are drawing.

NOTE: In the demonstration below, we have included a photograph of what we were observing, so you have a reference with which to understand the process. We want you to draw from life, **not from a photograph**.

Step 1. Begin with a gesture drawing, which is a rapid line drawing that is an overall summary of key physical characteristics, including movement, weight, shape, scale, and proportion. A linear gesture is often loose and records the

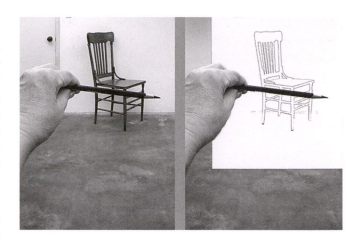

Figure 5.12
A thumbnail of Figure 2.10, which shows how to measure when drawing from observation.

way your eyes move over a form (Figure 5.13). For more on gesture drawing, see Chapter 3, Figures 3.11 and 3.12.

At this point, most of the lines are drawn along the **axes,** which represent the center of the form, not outlines. For the dog's leg in Figure 5.13, note how the first lines correspond to the skeleton, which act as an axis.

 VIDEO 11: Review Video #8 on Making Gesture Drawings

Figure 5.13
Gesture drawings convey the sense of the whole.

Step 2. Check your gesture drawing. Now is the time to determine whether and how everything you want to draw fits on the page. Decide to show the entire dog, or maybe focus just on the head and shoulders. Adjust your gesture drawing as needed (Fig. 5.14).

Figure 5.14
The gesture drawing helps you place the entire dog on the paper, if that is what you want, or to zoom in on a detail.

Practice some gesture drawings of trees, plants, your roommate, or whatever is around.

Step 3. Develop the fundamental defining features, using cross contours and basic volumes. Measure to compare the size of one part to another part and to get its placement and direction right (refer to Chapter 2 again).

In our illustration, the fundamental defining features of this dog are her rib cage, haunches, head, and legs. Make sure you draw these as volumes with cross contours, not as flat shapes (Figure 5.15).

Observe carefully how one area transitions into another. You will find distinct changes in direction where the dog has a joint, as in her leg. In other places, there will be smooth transitions, as between the rib cage and belly.

Figure 5.15
Find the major masses of the forms, using cross-contour lines and basic volumes.

F.Y.I.

Look up the sketches of Rembrandt van Rijn and Honoré Daumier to see other ways to make gesture drawings and add basic forms to them. Try their style of gesture drawing in your next sketch.

Step 4. Shading the form.

Add basic shading to show the top, bottom, sides, and front of the dog. The shading here is done with hatching and cross-hatching, but washes or smudged media would also work (Figure 5.16). Show clearly which sides receive light and which are in shadow.

Step 5. Adding cast shadows and final details.

After shading the dog to establish the three dimensions, add final details to the subject and to the background. In this example, we added the cast shadow over the front of the dog and more details (Figure 5.17).

Review the discussion of grouping values in Chapter 4, Figure 4.5, and remember that the white fur should be drawn as light gray when in shadow, as in the dog's neck. But it should be white where fully lit, as in the dog's back leg. Dark fur should be shown as a middle value when in the sun, and as a nearly black value in the shadow.

Figure 5.16
Shading the form to emphasize it as a three-dimensional volume.

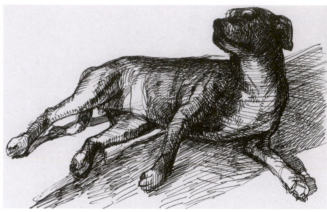

Figure 5.17
(Above). Finishing the drawing.

Figure 5.18
A historical example of a drawing using hatching to build volume.
ARTHUR B. DAVIES, *Josie*, 1892. Graphite, 6 ½ × 8 inches. John Davis Hatch Collection, National Gallery of Art.

Sketch complex forms, working systematically from gesture to final details.

FORESHORTENING

Sometimes you will draw a complex form and all parts will be equally close to you, or nearly so, as in Truck View #1 (Figure 5.19).

Often, however, some part will be moving toward you or away from you. Forms that were once in a line are now stacked behind each other, as in Truck View #2 (Figure 5.20). This is called foreshortening, and it presents a special set of challenges when drawing complex forms.

In a foreshortened view,

- Overlapping is essential.
- A receding axis can be observed: The axis defining the length of the truck (front to back) recedes in space.

- The foreground object projects forward: The front of the truck seems to push forward toward viewer.
- Close forms look bigger: The grill, being closer to the viewer, appears bigger than normal, and while the back appears smaller. While you know all the tires are the same size, the front ones look very large and the back one looks tiny.
- Diagonal lines dominate the drawing.

Figure 5.21 is a summary and review of the stages used to draw complex forms with a foreshortened view.

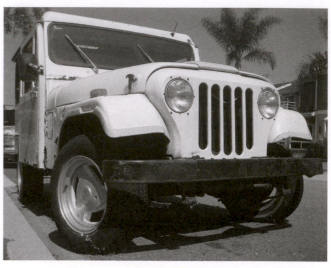

Figure 5.20
Truck View #2. A highly foreshortened view of the same truck.

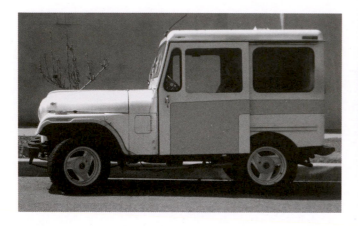

Figure 5.19
Truck View #1. Profile of truck. There is practically no foreshortening in this view.

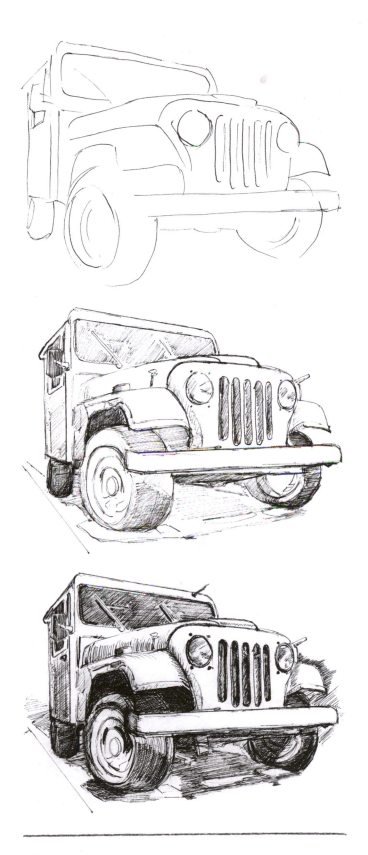

Figure 5.21
Drawing foreshortened complex forms in three stages.

Practice drawing complex forms with foreshortening and without it.

When you draw a foreshortened human figure, the most difficult problem is ignoring what you think you know and drawing what you see. In Figure 5.22, facial features do not line up in the way that you expect. Here, the eyes are level with the tip of the nose, and the ears are lower than the mouth. Using a pencil as a measuring tool will help you line up forms.

F.Y.I.

Research these artists to see how foreshortening adds dramatic impact to their work:

- Salvador Dalí painted various versions of the Crucifixion with foreshortening.
- Andrea Mantegna painted a famous image with extreme foreshortening called *Dead Christ*.
- Jacopo Pontormo made a number of drawings with foreshortened human figures.
- Parmigianino painted *Self-Portrait in a Convex Mirror* in 1524, in which his hand, in the foreground, is enlarged compared to the rest of his body.

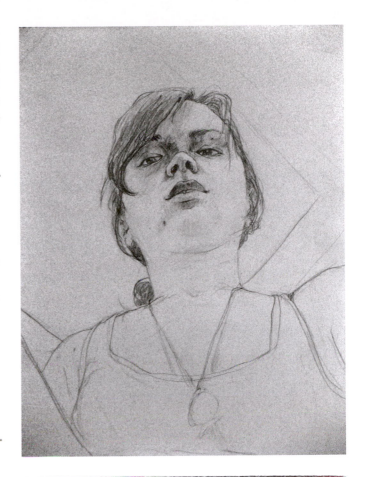

Figure 5.22
This self-portrait is rendered with facial foreshortening. LIANA SPOSTO, Untitled (foreshortened self-portrait), 2011. Graphite on paper, 24 × 18 inches. Student work.

CRITICAL ANALYSIS

From among all of the artists mentioned in this chapter's F.Y.I. boxes, choose two artists with very different approaches to shape and volume. Print out an approximately 2″ × 2″ version of a drawing from each, and paste them into the space below, adding the name of the artist.

1. **First Glance. Write at least two sentences about what strikes you visually about each drawing. What do you notice?**

 Drawing 1

 Drawing 2

2. **Describe how each uses shape and volume.**

 Drawing 1

 Drawing 2

3. **Analyze the expressive qualities of each.**

 Drawing 1

 Drawing 2

Combine shape and volume in your last drawing for this chapter. Sit in front of a mirror with a flat wall behind you, with a door and or a few windows. Stretch out your hand and point your finger in the mirror. Draw the foreshortened view of your hand and arm volumetrically. Draw the background using flat shapes.

SPACE

Figure 6.1
This artist used many devices to create the illusion of deep space, going far into the distance. *Mountain View*. Ink, wash and color on paper. Chinese School, Ming Dynasty (1368–1644), Victoria and Albert Museum, London, UK.

This chapter covers ways in which space exists in drawing, whether flat, shallow, or deep (Figure 6.1), and how this adds to meaning in your drawing.

ACTUAL AND ILLUSIONISTIC SPACE IN DRAWING

DEFINITIONS: Space in drawing is both **actual** and illusionistic. **Actual space** is the flat drawing surface (for example, a piece of paper), which is also called the **picture plane**. It has two dimensions: height and width. **Illusionistic** space is what appears to exist in the third dimension of depth. Such drawings have height, width, and the impression of depth, as if looking through a window.

Before you begin your drawing, you choose something to draw on: a piece of paper, a plank of wood, a concrete wall, and so on. That blank surface is your picture plane (Figure 6.2, left). It has height and width as its space.

Once you make a mark on that surface or draw a shape (for example, a circle), it appears as something against a background. That "something against a background" is the beginning of space in depth (Figure 6.2, right).

As a few other elements are added, suddenly the space becomes more complicated. For the diagrams in Figure 6.3, describe the kinds of space you see. What surface is in front in each diagram? What is in the background? What appears to be close? What is distant? When does the circle look like a hole, and when like a volumetric object?

Figure 6.2
The picture plane (left), and a shape drawn on it (right).

Figure 6.3
Describe the kinds of space in these diagrams.

In the outline shapes below, try some drawings that shift your perception of space.

FIGURE/GROUND RELATIONSHIPS

DEFINITION: The **figure/ground relationship** refers to perceiving an object (or figure) against a background (or ground). Figure 6.3 shows several different figure/ground relationships.

Any mark on a surface creates a figure/ground relationship. This is also known as a negative space/positive shape relationship. The empty space around an object becomes the **negative space**, while the object becomes the **positive shape.** Your perception of which is the negative space and which is the positive shape can shift. At times, the negative space and positive shape can be visually interchangeable (Figure 6.4).

Also, in the black and white pattern, the figure/ground relationship can shift. Of the black shapes and the white shapes, which are objects and which are background?

Figure 6.4
It is possible to see a white circle on top of a patterned paper, or also as a white hole cut from a patterned surface, but not as both at the same time. This is a shifting figure/ground relationship.

F.Y.I.
M. C. Escher produced many drawings and prints with shifting figure/ground relationships. Look at two or three of his images until the negative shapes become positive, and then focus differently so that the images flip.

Look on the Internet for images of the classic face/vase optical illusion. In the space below, try drawing something else that has that kind of shifting negative space/ positive shape.

OVERLAPPING, COMPARISON OF SIZE, AND PLACEMENT TO SHOW SPACE

Simple devices can be very effective to create space in a drawing. Overlapping is perhaps the simplest (Figure 6.5).

Overlapping can be even more effective when it is combined with changes in size (Figure 6.6). Also, placement affects the perception of closeness. Shapes that are lower in the drawing often seem closer than shapes placed higher up (Figure 6.6). Looking through something also establishes distance, as you can see with the arch and railing in Figure 6.7.

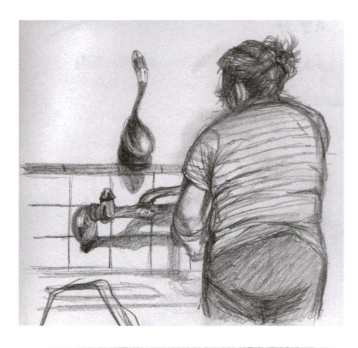

Figure 6.5
Overlapping effectively shows space. Here the woman is clearly in front of the faucets which protrude from the wall. CYNTHIA ANGULO, *A Day in the Kitchen*, 2010. Pencil on paper, 8.5 × 11 inches. Student work.

Figure 6.6
Simple overlapping at left; overlapping plus size change in the middle; overlapping plus size change plus placement at right. Space is shown most effectively when all three devices are combined.

Figure 6.7
Looking through the arch and railing to see the distant boat and buildings. MARY CASSATT, *View of Venice*, 1887. Drypoint. National Gallery of Art, Rosenwald Collection.

Choose simple forms and experiment with showing space using overlapping, size change, and placement.

You can vary how deep or shallow the space seems to be. Figure 6.8 illustrates a shallower space than Figure 6.9. The skull still life exists on a narrow shelf, with the background pushed up close to the view. In Figure 6.9, the space seems to trail out into the background as the rings get smaller, are more spread out, and recede diagonally.

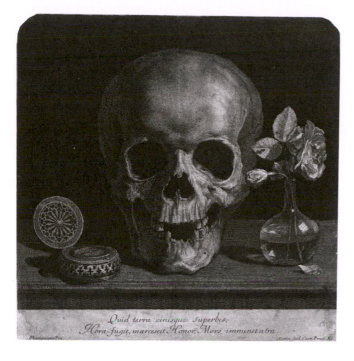

Figure 6.8
This still life shows shallow space. JEAN MORIN, *Still Life with a Skull and a Vase of Rose*, 1645/1650. Etching with engraving on laid paper, 15 × 12.5 inches. National Gallery of Art.

Figure 6.9
This still life shows a greater sense of depth. RICHELLE GRIBBLE, *77 within 84 Round Paper Stripes*, 2000. Graphite on paper, 16 × 20 inches.

Experiment with overlapping, placement, and size variation for sketches with more or less depth.

SHOWING SPACE WITH LINEAR PERSPECTIVE

Linear perspective is one method used for representing space in a flat image. It operates on the theory that parallel lines appear to converge as they recede (Figure 6.10). They seem to meet at a **vanishing point** on the horizon line, which is the viewer's eye level in the scene. Linear perspective works for drawing space with geometric volumes with clear edges.

There are three kinds of linear perspective: one-point, two-point, and three-point. We will also look at circles in terms of perspective.

VIDEO 12: One-, Two-, and Three-point Perspective and Circles and Cylinders in Perspective

One-point perspective has the following attributes:

1. The front plane is closest to you. It does not recede, and it is defined as a shape. Horizontal lines remain horizontal, and vertical lines remain vertical on all front-facing planes (Figure 6.11).
2. All side planes seem to diminish toward one vanishing point on the horizon line (Figures 6.10 and 6.11).
3. The vanishing point can often be located within the picture plane (Figures 6.10 and 6.11).
4. All drawn objects should be placed relative to the vanishing point and horizon line (Figures 6.11 and 6.12).
 * If you look up and see the bottom of an object, then place it above the horizon line in the drawing.
 * If you look down and see the top of an object, place the object below the horizon line.
 * If your object is located to the left, place it left of the vanishing point, and if it is located to the right, place it on the right side of the picture plane.
5. One-point perspective has limitations. If objects are too far to the left or right of the vanishing point, distortions occur.

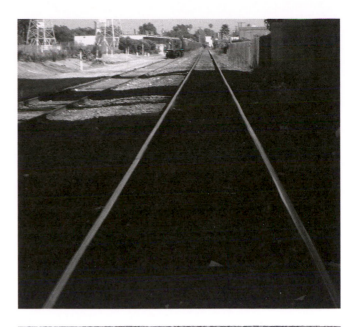

Figure 6.10
Parallel lines appear to converge as they recede into the distance.

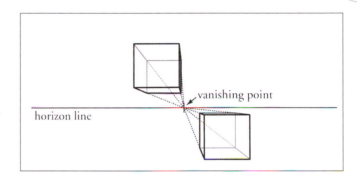

Figure 6.11
One-point perspective diagram.

F.Y.I.

Look into the development of linear perspective during the Renaissance. Leonbattista Alberti was an Italian Renasissance scholar, architect, mathematician, and scientist. His interest in optics and geometry made him an advocate for perspective drawing. Contrast his works with earlier European works.

Figure 6.12 shows the relationship between seeing cubes and drawing them a linear perspective diagram. All cubes are located in relation to the vanishing point and the horizon line. You can see the right side of the cubes located on the left, . . . and vice versa. When do you see the tops or bottoms?

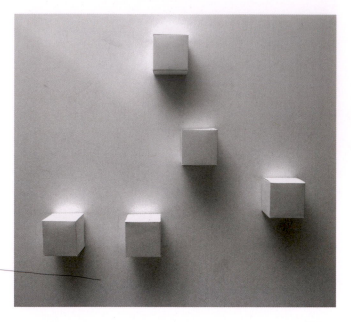 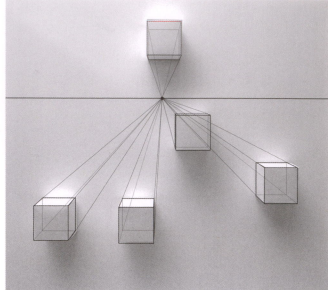

Figure 6.12
Relationship between seeing cubes and drawing them in one-point perspective.

Arrange a couple of rectangular objects (TV remote, tea box, and book, for example) with one side facing you, and draw them in one-point perspective.

With linear perspective, you can draw volumes that are smaller than you, like the boxes in Figures 6.13 and 6.14, which you could hold in your hand, and which you see from the outside.

You can also draw big boxes, such as a room (Figure 6.15). The top of the room (or box) is the ceiling, while the bottom is the floor. You are inside the box, so you don't see the outside, like you can with a box that you hold.

Figure 6.13 and 6.14
The images above show a one point perspective box seen from the outside. KERRIE ROBINSON, (above left) *One-point Art Box Study*. 2005. Conte crayon on paper, 18 × 24 inches. Student work. AMANDA ELGSEDER, (above right) Untitled, 2005. Conte crayon, 18 × 20 inches. Student work.

F.Y.I.

Find examples of the works of Piero dell Francesca, Fra Angelico, and Sandro Botticelli that illustrate one-point perspective. Also find some drawings by Vincent Van Gogh in one-point perspective is used.

Figure 6.15
This image at left shows a one-point perspective box (the room) seen from inside. ANDREA BEAHN, *Library*, 2011. Ballpoint pen and charcoal, 18 × 24 inches. Student work.

Sketch a room from a one-point perspective. Include smaller objects inside the room.

Two-point perspective has the following attributes (Figure 6.16):

1. A single edge (not a flat surface) of a rectangular volume is closest to the viewer. This is defined by a line.
2. All side planes appear to recede to one of two vanishing points. All top and bottom planes vanish to both points.
3. Vertical lines remain vertical and parallel to each other.
4. Horizontal lines are rendered as diagonals, except where they fall exactly on the horizon line.
5. Vanishing points are usually located outside of the picture plane.

Figure 6.17 shows the relationship between the photos of cubes and a two-point perspective drawing. The gray area indicates the drawing surface and shows the vanishing points well outside of that area. In two-point perspective drawings, you often have to (1) add extra paper to plot vanishing points or (2) estimate the location of vanishing points and make your lines consistent with them.

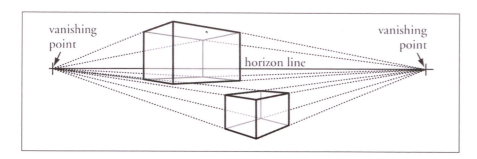

F.Y.I.

Look up the work of Robert Stackhouse, a contemporary painter and sculptor whose perspectival drawings feature archetypal structures.

Figure 6.16
Two-point perspective diagram.

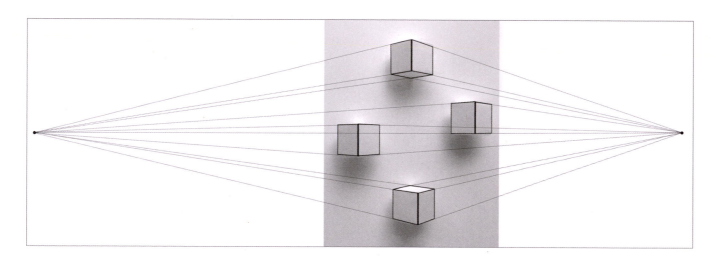

Figure 6.17
Two-point perspective, the picture plane, and location of vanishing points. Compare this to the one-point perspective diagram in Figure 6.11.

Practice two-point perspective with some common rectangular objects.

Two-point perspective is used to show spaces that are small like a table top (Figure 6.18) or large like a city square (Figure 6.19). In each drawing, can you locate the viewer's eye level (which is also the horizon line)? In which scene is the viewer closer to the subjects?

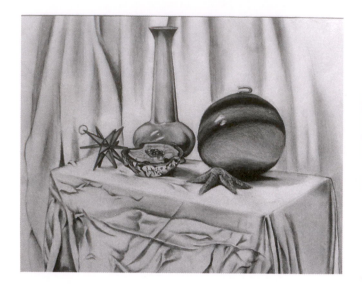

Figure 6.18
A small table top in this image is drawn in two-point perspective. DAVID CARLOCK, *Still-Life Composition*. Ebony and colored pencils. Student work.

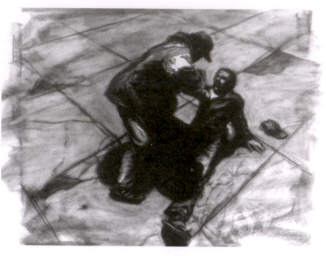

Figure 6.19
A broad space in this image is shown in two-point perspective. CHRIS CHINN. *Drawing for Street Fight*, 2005. Charcoal on paper, 22 × 30 inches.

Draw objects or spaces with two-point perspective. Think about the viewer's location.

Three-point perspective has the following attributes (Figure 6.20):

1. A single point of a rectangular volume (not an edge and not a flat surface) is closest to the viewer and is defined by a dot.
2. There are three vanishing points in three-point perspective. Two are on the horizon line, and the third is above the horizon line if you are looking up, or down below it if you are looking down (Figure 6.19).
3. All planes recede to two of the three vanishing points.
4. No sets of lines remain parallel. All converge.

In three-point perspective drawings, the vanishing points often fall far outside of the picture plane, as you can see in Figure 6.21. The shaded area represents your drawing paper. If it were 18″ × 24″, then you would need an additional piece of paper 7′ high and 22′ feet wide to plot the vanishing points. This is rarely practical.

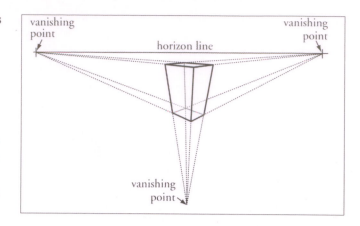

Figure 6.20
Three-point perspective diagram, looking down.

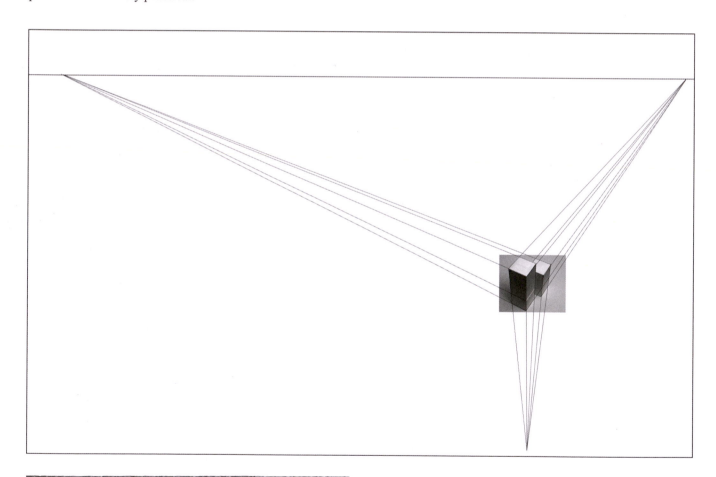

Figure 6.21
Plotting the vanishing points in a three-point perspective drawing.
Right and left vanishing points are on the horizon line. Because
you are looking down, the third vanishing point is down low.

The practical solution is to use your pencil to determine angles, as described in Chapter 2 and illustrated here in Figure 6.22. Use your pencil to find the direction of the edges. Your knowledge of the theory behind three-point perspective should help you visually check your final drawing for accuracy.

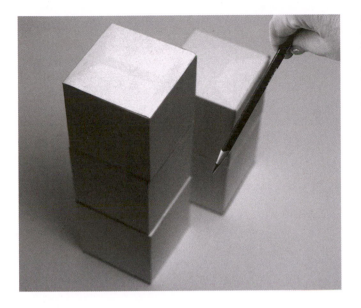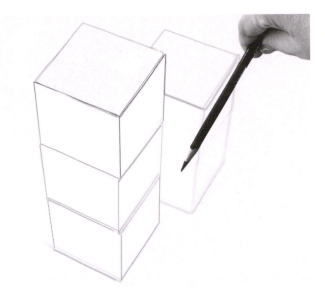

Figure 6.22
Use your pencil to determine the direction of edges in a three-point perspective set up, and then reproduce that angle in your drawing.

Position yourself at the corner of a very tall building, either looking up from the ground or looking down from the top. Take a picture with your cellphone or camera. Print the picture, glue it here, and make a diagram that shows the three vanishing points.

Figure 6.23 is an example of three-point perspective in which the third vanishing point is up high because you are looking up at the columns. In contrast, in Figure 6.22, the third vanishing point for the boxes is down low, because you are looking down on the boxes. Whether you are looking up or looking down, however, the right and left vanishing points are on the horizon line.

F.Y.I.

In three-point perspective, vertical shapes seem to taper as they get higher and higher. The Greeks understood this, so when they built their temples, they made their mighty columns a bit thinner as they got taller, so that there would be the optical illusion of greater height. Can you explain why they did this?

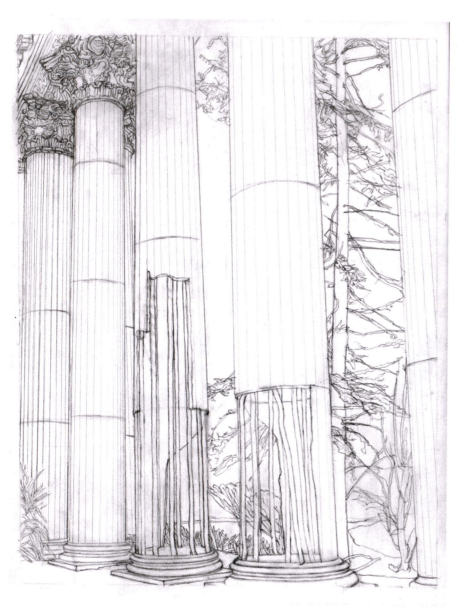

Figure 6.23
This image of columns shows three point-perspective, looking up. **KRISTIN CALABRESE**, Untitled (Palace of Fine Art). Illustration for *Shipwrecks and Other Drownings* by Stewart Lindh, 2007. Graphite on bristol board, 12 × 9 inches.

Practice Three-Point Perspective

CIRCLES AND CYLINDERS IN PERSPECTIVE

Circles and cylinders in perspective have the following attributes (Figure 6.24):

1. Circles drawn in perspective are rendered as ovals when not at eye level.

2. A cylinder is like a stack of circles.
3. When looking straight down on a cylinder, the opening resembles a circle.
4. As the cylinder moves toward eye level, its cross-sections go from fatter ovals to increasingly thin ovals. At eye level, a cross-section of a cylinder looks like a straight line.

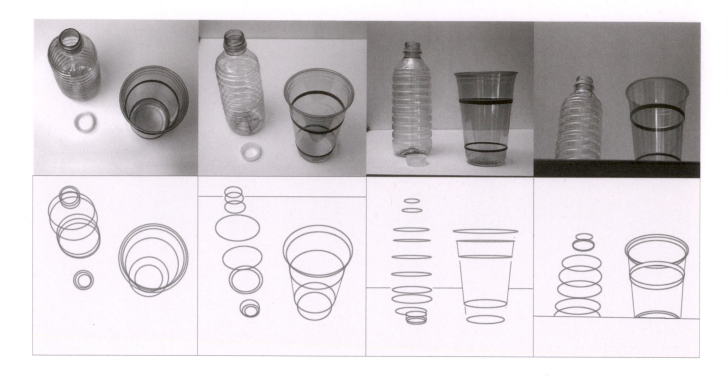

Figure 6.24
Drawing circles and cylinders in perspective. Notice how the back edge of the table (horizon line) shifts in the different points of view.

Analyze the rendering of decorative glasses in Figure 6.25. What is the viewer's point of view? Which parts of the cylinders seem closest to circles, and which seem more like flattened ovals? Why?

Figure 6.25
Cylindrical forms in space are shown with perspective drawing. JANET FISH, *Museum Glass*, 1975. Lithograph on paper, 37 ³/₁₆ × 29 ⁹/₁₆ inches. Jewish Museum, New York, NY.

Draw a collection of cylindrical objects.

ATMOSPHERIC PERSPECTIVE

Another way to create space in a drawing is **atmospheric perspective** (also referred to as **aerial perspective**). The atmosphere changes the appearance of distant things, making them blurred, less detailed, and low contrast. Distant objects blend into their surroundings. In the mountain landscape in Figure 6.1, this effect is visible in the light-gray hazy peaks in the distance, compared to the crisp detail and high contrast of the nearer hills and trees. In Figure 6.26, the artist depicted very great depth in space by showing the distant city with soft edges, no details, and light-gray values.

Figure 6.26
With atmospheric perspective, distant forms appear blurred and soft. JAMES ABBOTT MCNEILL WHISTLER, *Nocturne*. Lithograph. National Gallery of Art, Rosenwald Collection.

F.Y.I.

A few artists whose drawings have strong atmospheric qualities are Georges Seurat (19th-century conté drawings), Musumi Morikage (17th-century ink wash landscapes), and the contemporary Chinese painter, Yun-Fei Ji. Find other examples in photographs of landscapes.

Draw a distant view on a foggy or smoggy day. In the drawing, for added contrast, include something that is close to you.

EXPRESSIVE USE OF SPACE

Artists can choose to manipulate, distort, or invent space to enhance the meaning of their drawings. Sometimes they show space that is not clearly defined. In Figure 6.27, the viewer can see abstract forms as either receding or projecting through the picture plane. In Figure 6.28, the jumbled space contributes to a sense of disorientation and mystery.

Figure 6.28
Space is used expressively. The interior is strange and dreamlike. GIOVANNI BATTISTA PIRANESI, *The Arch with a Shell Ornament*. Etching, engraving, scratching, sulphur tint or open bite, drypoint.

Figure 6.27
This artist used abstract imagery and ambiguous space to make up the entire composition. AUTHOR WORK, Untitled, Conte, charcoal, pencil, crayon on paper, 17 × 23 inches.

Figure 6.29 is an example of a representation of distorted space. The staircase appears to be based on two-point perspective, but it looks rickety, exaggerated, or curious because there are actually multiple vanishing points, due to distortion. Notice that the vertical lines are not quite vertical.

Figure 6.29
This image shows the use of distorted linear perspective. MARIANNE BENNETT, Untitled, 2007. Conte crayon on craft paper, 18 × 30 inches.

Create a sketch with distorted space, ambiguous space, or both.

Shallow or deep spaces are also expressive devices. Shallow space draws the viewer into greater intimacy (Figure 6.30). Deep space can be overwhelming or grandiose or isolating (Figure 6.31).

Figure 6.30
This is an example of shallow space making up a major part of the composition. CECELIA DAVIDSON, *Zebra Leaf*, 2013. Graphite on paper, 4 × 6 inches.

Figure 6.31
The people appear dwarfed in this overwhelming space. JOSEPH PENNELL, *Concourse, Grand Central, New York*, 1919. Etching. National Gallery of Art.

Use deep or shallow space for expressive purposes.

Invented space may seem convincing in some ways, but it is also utterly incredible (Figure 6.32).

Figure 6.32
This image shows an invented space, with a wire-frame structure and a wave running through it. FRANCISCO HERNANDEZ, *Untitled.* (detail), 2012. Ink on paper, 8 × 10 inches. Student work.

CRITICAL ANALYSIS

Find an architectural drawing of interior spaces, which are intended to appear real. Next, find a drawing of an invented or illogical space (look at M. C. Escher or Giovanni Battista Piranesi). Print out an approximately 2″ × 2″ version of a drawing from each, and paste them into the space below, adding the name of the artist.

1. First Glance. Write at least two sentences about what strikes you visually about each drawing. What do you notice?

 Drawing 1

 Drawing 2

2. Describe whether and how each uses figure/ground relationships, linear perspective, and atmospheric perspective.

 Drawing 1

 Drawing 2

3. Describe how each is similar to and different from photographic images of interior spaces. How are they different from photographic images of landscapes? How are they different from each other?

Make a drawing that blends areas of invented or illogical space with areas of ordinary, observed space.

TEXTURE

Figure 7.1
Textures can be drawn to imitate the surfaces of things as they exist in the world. But they can also be used in a surreal, dreamlike, or fantastic fashion as rendered in this example. RENE MAGRITTE, *The Thought Which Sees.* Graphite on paper, 15 ¾ × 11 ¾ inches. Gift of Mr. and Mrs. Charles B. Bensenson (261. 1966) The Museum of Modern Art, New York NY, USA.

Textures provide visual richness and tonal variety. They evoke the sensation of touch and thus engage another sense for viewers. They can add to the emotional impact of your drawing as well as having enormous visual appeal. They draw the viewer in with the amazing wealth of detail (Figure 7.1).

DEFINITION: Texture is a surface quality that affects feel or appearance. Textures can be visual or tactile. **Tactile** textures are those you can actually feel by touch. **Visual** textures are made with value and line and actually have no tactile qualities but appear as though they do.

TEXTURES INHERENT IN MEDIA

Drawing on a textured surface can add interest to your work (Figure 7.2).

Figure 7.2
Canvas, paper, and wood are all good surfaces for drawing. Each supplies a distinct texture.

In addition, the media has its own textural properties. When you combine a variety of media with textured drawing surfaces, you can produce unlimited and sometimes surprising results (Figure 7.3).

Figure 7.3
Combine various media with differently textured surfaces and see the result. Our examples show conté on canvas, watercolor on rough paper, and charcoal on wood.

Try different media on various textured surfaces. Glue six 3″ × 3″ examples of these experiments on the page below.

Texture is evident in the artwork in Figure 7.4. The artist drew directly on a lithographic stone with a waxy crayon, and this was used to make a print. The texture of the stone and the crayon are clearly visible in the final work.

F.Y.I.

Juan Gris and Georges Braque collaged different kinds of paper onto their drawings to increase texture. They used newspaper, playbills, menus, and found objects. Notice how this increases the visual interest of their drawings.

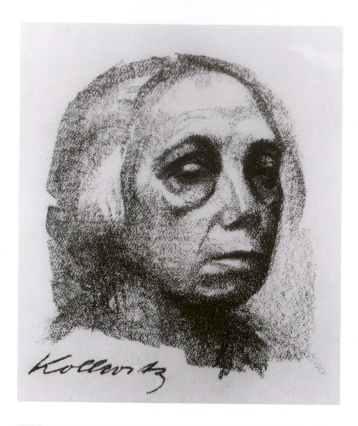

Figure 7.4
The grainy texture of lithographs. KÄTHE KOLLWITZ, *Small Self-Portrait*, 1920. Lithograph.

Find a sheet of embossed wrapping paper, flocked wallpaper, sandpaper, or rough cardboard. Glue it onto this page and draw on it with various media.

TEXTURES THAT STIMULATE ACTUAL OBJECTS AND SURFACES

Another way to introduce texture into your drawing is to carefully render it. Your drawing can visually simulate tactile qualities, such as sharp, broken surfaces (Figure 7.5), the softness of a satin fabric (Figure 7.6), or the roughness of an unshaven beard. Textures can be drawn either with blended values or with the accumulation of many individual marks.

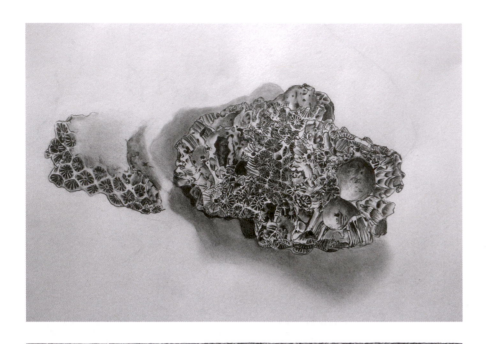

Figure 7.5
With careful observation and controlled rendering of values and marks, the artist successfully imitated the surface of an actual shell, DAVID CARLOCK, *Pawley's Island Shell*. Graphite on a smooth paper, 18 × 24 inches.

Marks are used to show almost all the textures in the shell drawing shown in Figure 7.5. When making textures with marks, pay attention to direction. As you can see, these encrustations grew organically in varying directions, with broken parts and exposed structures. The accumulated dots, crisp blunt strokes, and fine wavy lines indicate these textures. Figure 7.16 is another example of indicating texture with two-dimensional marks.

In contrast, you can use smoothly blended values to convey the silky texture and transparency of fabric (Figure 7.6). Figure 7.7 compares the details of these different drawing methods.

F.Y.I.

Investigate the different ways that artists use texture. For example, the artist Vija Celmins drew amazingly detailed textures with blended values. In contrast, the Dreamtime paintings of Australian Aboriginal artists are created with an accumulation of dots, dashes, and other marks to make maps of their physical world, their history, and their cosmos.

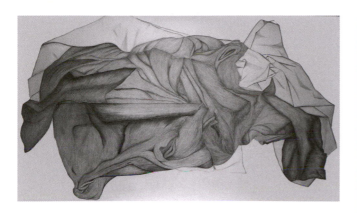

Figure 7.6
Smoothly blended values simulate the soft folds of fabrics.
ALEXANDER HOWLAND, Untitled. Colored pencil on paper, 72 × 96 inches, 2011. Student work.

Figure 7.7
Comparing details of Figures 7.5 and 7.6 to see textures drawn with marks and values.

Draw various textures that you observe. Try using marks and using blended values.

TEXTURES USED FOR EXPRESSIVE PURPOSES

Bringing to mind the sense of touch in addition to sight, textures can be effectively used for expressive purposes. In Figure 7.8, the huge clump of drooping flowers seems suspended between life and death, and between beauty and decay. The drawn textures convey a gut feeling of touching the decomposing flowers, which provides a stronger emotional reaction. This response is reinforced when you see the partially hidden skeleton and hand.

Figure 7.8
The drawing above illustrates how texture can add a visceral impact to the expressive content of a drawing. CAROL GOLDMARK, *Flora Corpori/Innominate #1*, 2007. Mixed media on vellum, 42 × 52 inches.

Textures in the tree in Figure 7.9 are also used for expressive purposes. The tree trunk is split in the middle and seems about to break apart. The gnarled roots seem like claws holding onto the ground, while the textures of the bark make it seem very weathered and aged.

Return to Figure 7.1, where textures are used for a surreal effect, which is a kind of expressiveness. The background sky has wood grain, while the silhouettes of men are filled with night and day sky.

Figure 7.9
The textures rendered in the trunk convey the idea of a weather-beaten, aged tree. RACHEL WOELFEL, *Campus Tree*, 2011. Charcoal pencil on paper, 24 × 18 inches. Student work.

In the space below, apply a texture to the drawing of something completely different, and experiment with the kind of expressive qualities you can create.

ABSTRACTED, EXAGGERATED, AND INVENTED TEXTURES

DEFINITION: Abstract refers to imagery that is simplified or distorted from reality. **Abstracted texture** has some basis in observation, but it has been modified or changed in a significant way. **Exaggerated textures** are also based on observation, but the texture's attributes have been overstated. **Invented textures** emerge completely from the artist's imagination.

Abstracted, exaggerated, and invented textures are used by artists for greater impact in their work.

In Figure 7.10, the textures of fur, water ripples, falling rain, and wood slats are all more simple and orderly than they appear in nature. These are **abstracted** textures.

Genesis 6:19: Bring two of every living creature into the ship in order to keep them alive with you. They must be male and female.

Figure 7.10
Abstracted textures are based on observation but are modified by simplification or distortion, as seen in the image above. BEAUVAIS LYONS, 2011. *Genesis 6:19.* Hand printed lithograph on Somerset Antique, 11 × 14 inches.

What happens when you take disorderly textures and find structures in the chaos?
Draw it.

The texture of the moon surface is **exaggerated** in Figure 7.11. Also, the sizes of the birds, trees, and plants are completely unrealistic in relationship to each other. This distortion helps to emphasize texture and to create a conceptual and fantastic view of the forest at night.

Figure 7.11
The texture of the face of the moon is exaggerated. STAS ORLOVSKI, *Nocturne with Pine Tree and Bird*, 2009. Charcoal, graphite, ink, oil, gouache, monoprint and xerox transfer on paper laid on canvas, 55 × 44 inches.

Draw four textures. Next to them, try out some abstracted or exaggerated versions of them.

Textures can be **invented** in a drawing. Invented texture comes completely from the artist's imagination and is created by the accumulation of many marks (Figure 7.12).

Figure 7.12
The drawing was rendered with invented textures throughout. AUTHOR WORK. *Landscape.* Color pencil on smooth paper, 12 × 12 inches.

TEXTURE TO PATTERN

DEFINITION: Pattern is the repetition of one or more visual elements with intervals in between.

Texture and pattern are related. Shrinking a pattern to a small size can make it look like a texture. Enlarging a texture can look make it look like a pattern. This can be seen in the photos of the woven fabric in Figure 7.13.

An object or texture that is enlarged or compressed and compared to the original state represents a change in **scale**.

Figure 7.13
The photo on the right is an enlargement of the textured weaving on the left. Interestingly, as the weaving is enlarged to look like a pattern, another level of texture emerges in the windings of the individual cords.

Enlarge some texture drawings you have already made in the exercises in this chapter to a scale at which pattern becomes evident.

Drawings with both texture and pattern make this relationship evident. In Figure 7.14, the curving lines of the larger-scale forms appear as patterns, while the accumulation of intricate whorls, dots, and circles appear to be textures. Another way to think of these scale differences is **density**, the degree to which a given area is filled or crowded. Denser areas appear as texture. Areas of less density tend to look like a pattern.

F.Y.I.

Look at manuscripts from medieval Europe, from 17th- and 18th-century Persia, and from contemporary Hindu paintings on silk. All are embellished with intricate patterns. You can visually dive into them, or you can back up and study the whole page, which makes the written words and the patterns appear to combine into one texture.

Pattern can be used to organize a composition; texture gives it richness. In Figure 7.15, the long, looping branches form a pattern that frames and emphasizes the figures.

Figure 7.14
In this fantasy line drawing, the artist included both texture and pattern in the composition. FRANCISCO HERNANDEZ, Untitled, 2012. Ink on paper, 8 × 10 inches. Student work.

Figure 7.15
A historic example of a work incorporating texture and pattern. ISRAHEL VON MECKENEM, *Ornament with the Tree of Jesse.* Print. Rosenwald Collection, National Gallery of Art.

Do some texture and pattern studies. Focus on scale and density.

By experimenting with various media, you can give a very different look to a pattern and texture drawing. Figure 7.16 illustrates the use of heavier, blacker tones of charcoal. The image with dark values overall is more closed in compared to the airiness of the delicate lines in Figure 7.14.

Figure 7.16
Texture and pattern were rendered in values, using charcoal. The effect is very different from the line drawing with texture and pattern in Figure 7.14. STEPHEN TAYLOR, *Thorn Bush in Black and White*, 2010. Charcoal on illustration board, 40 × 40 inches. Student work.

Using an example from your research, translate linear textures into value textures, and vice versa.

TEXTURE, PATTERN, AND SPACE

Transitions from pattern to texture can show foreground and distance. In Figure 7.17, the pattern-like marks at the bottom of the page are bigger and are spaced more widely, to indicate the foreground. As the image "moves" to a greater distance, the marks become more texture-like and more closely spaced. Vincent van Gogh produced many drawings of orchards, crops in fields, and meadows with trees that combined textures and patterns to show the depth of space in the countryside.

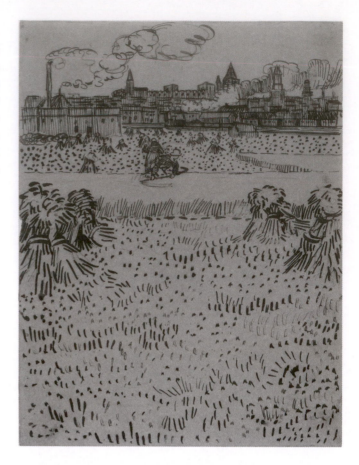

Figure 7.17
Van Gogh used pattern and texture to move our eyes from close space to distant space. VINCENT van GOGH, *The Harvest*. Drawing. National Gallery of Art. Collection of Mr. and Mrs. Paul Mellon.

CRITICAL ANALYSIS

Find examples of texture in the natural world and in the constructed world. Examples from nature could include tree bark, animal fur, feathers, leaves, and so on. Constructed textures could include metal grates, window screen, manhole covers, shoe treads, cell phone covers, and so on. Make photographs, sketches, rubbings, or photocopies of these materials and paste them below.

1. Compare and contrast the regularity of the mechanically produced textures with natural ones. Which can be described as geometric? Which have regular or irregular intervals?

2. Which do you find most appealing? Which are you more likely to use in your drawing, and why?

Use textures and patterns to draw a broad garden with flowers, grassy areas, fencing, and walkways, emphasizing the differences of each.

COLOR

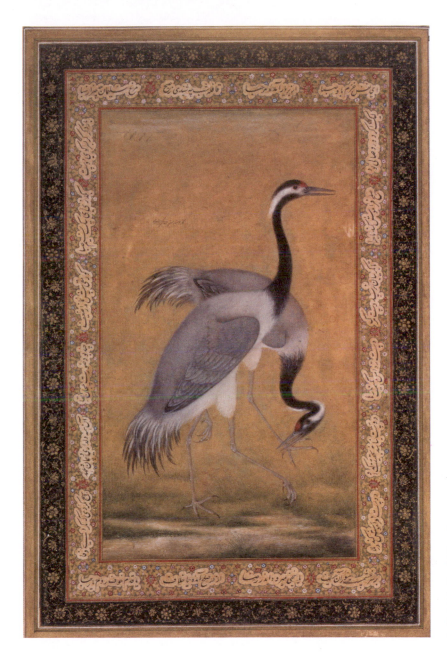

Figure 8.1
The use of color is optional in drawing, and can be
used in a sketch-like way, or in a way that resembles
painting as the image to the left illustrates. USTAD
MANSUR (Nadir al'Asr), *Pair of Saras.* Brush line
drawing, ink on paper. India, Mughal. Victoria and
Albert Museum, London, UK.

The use of color in drawing is an option for artists. You can
add color to your drawing by choosing a colored media or a
colored ground. Or you can draw entirely in color. This
chapter will give you an understanding of color theory and
the expressive impact of color in drawing. Color can be an
accent added to a quick sketch. We will also show examples
of using color that approaches the finish of a painting
(Figure 8.1).

COLOR MEDIA

DEFINITION: Colors are a phenomenon of vision. It is one quality you perceive when light reflects off an object, enters your eye, and is deciphered by your brain. In art, there are many types of media that produce a wide array of colors.

The varieties and types of color media are almost endless. From among them, we have chosen the following media as best suited for a sketchbook:

- Colored pencils (regular or watercolor pencils)
- Colored markers
- Oil pastels (soft intensely colored crayons)
- Gel or ballpoint pens with colored ink
- Conté crayons
- Watercolor

Here is some basic color terminology:

The name of a color, such as "blue," "orange," or "green," is also called a **hue**.

In Chapter 4, we defined value as black and white with shades of gray in between (**achromatic values**, which lack color). Color has **value** as well, but these are called **chromatic values**. You can change a color's value (its lightness or darkness) by mixing it with black or white. A **tint** is a mixture of a color plus white. A **shade** is a mixture of a color plus black (Figure 8.2). In its pure state, a color has a **natural value**. Unmixed red has a natural value that compares to middle gray. Unmixed yellow has a light natural value. Unmixed blue has a dark natural value (Figure 8.2).

Mixing a hue with any other hue, or mixing it with black or white, lowers its saturation or intensity. Full **saturation** or **intensity** is an unmixed hue at its purest (Figure 8.3). In Figure 8.3, the intensity of the red diminishes without an appreciable change in its value.

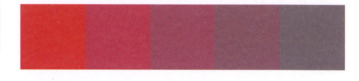

Figure 8.3
A red hue gradually mixed with increasing amounts of gray. The red at left is most saturated, and becomes progressively less saturated moving toward the gray at right.

Figure 8.2
An achromatic value scale at top and three chromatic value scales below. The red, blue, and yellow scales show value changes with less media, as in colored pencil applied lightly versus heavily rubbed in. The green scale shows changes in value that result when a hue is mixed with black or white.

COLOR RELATIONSHIPS

In traditional color media, such as paint or colored pencils or pastels, there are three primary hues: red, yellow, and blue. Within any media, **primary hues** are those which can be mixed to produce the greatest variety of other colors. **Secondary hues** are the result of mixing two primary colors. In traditional color media, the secondary colors are green, orange, and purple (Figure 8.4). A **tertiary hue** is a mixtures of a primary and nearby secondary color. In addition, thousands of other colors are possible with other mixtures.

A color also has a **temperature**, which is the perception of coolness or heat. Green, blue, and purple are generally considered to be cool colors, whereas yellow, orange, and red are warm. Temperature is relative, however. Green might be considered cool, but next to blue, it might look warmer.

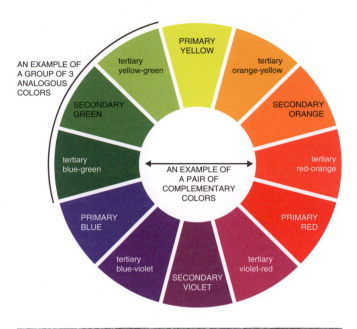

Figure 8.4
The color wheel illustrates color relationships in traditional color media, showing primary, secondary, and tertiary hues. Analogous and complementary relations are also illustrated.

Try out your colored media. Apply it heavily or very lightly. Mix. Create chromatic value scales.

Continue experimenting with your colored media, trying different applications and mixtures.

Complementary colors are opposite each other on the color wheel (Figure 8.4). When seen side by side, complementary pairings of colors seem more vibrant than when they are viewed separately. This juxtaposition is often used for emotional expression. When mixed, complementary colors produce gray or dull brown. See Figure 8.5 and 8.6. The scale below illustrates the intensities of the two complementary colors, that is, their degree of brightness and dullness.

Figure 8.5
Complementary colors side by side (left) and mixed together (right), using colored pencils.

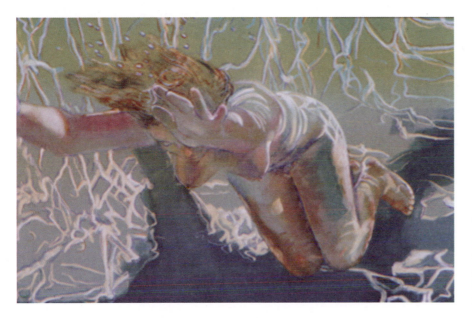

Figure 8.6
This is an example of an artwork featuring complementary colors. RUTH WEISBERG, *Separating the Waters II*, 1996. Monotype on paper, 19.75 × 27.75 inches.

Do some color mixing below, using regular colored pencils, watercolor colored pencils, gel pens, or watercolor.

Do sketches with complementary color pairs.

Analogous colors are next to each other on the color wheel (Figure 8.4). Because analogous colors are visually similar to each other, they do not create such vibrant contrasts when paired. Mixtures made from analogous colors remain at high saturation. In a drawing, analogous color schemes contain closely related colors (Figures 8.7 and 8.8).

Figure 8.7
Analogous colors side by side (left) and mixed together (right), using colored pencils.

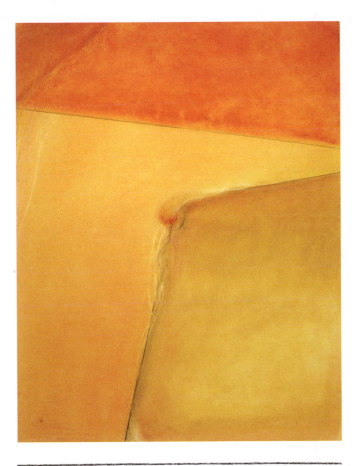

Figure 8.8
The artist has used an analogous color scheme of oranges and yellows to create the color fields in this composition. AUTHOR WORK, *Inner Image VII*, 1988. Pastel and pencil on paper, 36 × 24 inches.

 VIDEO 14: Using Color Media

Do some sketches with analogous colors.

COLORED GROUNDS

Another way to add color to a drawing is to use a colored ground. Drawing on a surface that is not white has some advantages. Viewers notice the color, whereas white paper becomes invisible. You will notice it more, too, as you are drawing. Color makes a more dramatic background than white, and its temperature can add to the expressive quality of the drawing, as in Figures 8.9 and 8.10. A different emotion is associated with the figure drawn on the cool blue background versus the one drawn on the warm orange.

A common example of a colored ground is colored paper. A wood panel is a colored ground that also has texture. You can also create your own colored ground by first coloring your drawing surface.

Figures 8.9 and 8.10 show two drawings rendered with black and white only, but on different colored grounds. The colored grounds have a huge impact on the overall effect of the drawings.

F.Y.I.
Look up some of the many artists who drew on colored grounds. Three examples are Giambattista Tiepolo, Edgar Degas, and Mary Cassatt. Examine how the different colored backgrounds affect the content of the drawing.

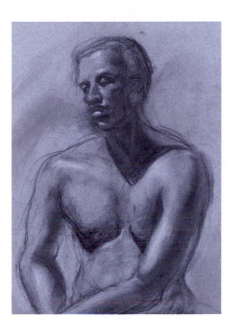

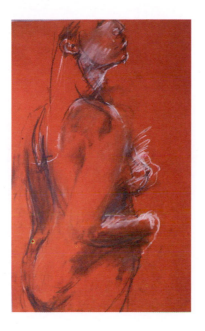

Figure 8.9
CECELIA DAVIDSON, *Nude Male* (detail), 2009. Black and white conté on blue paper. Full image 18 × 24 inches.

Figure 8.10
AUTHOR'S STUDENT WORK, Untitled figure study, 1966. Black and white conté on red-orange paper.

Draw on this colored ground, experimenting with black, white, and colored media.

Draw on this colored ground, experimenting with black, white, and colored media.

Using colored media on colored ground increases the visual interest. The white face with touches of red, yellow, and blue is more vivid because of the yellow background in Figure 8.11. The finished face contrasts with the sketchy body.

F.Y.I.

Henri de Toulouse-Lautrec often drew in vivid colors on toned paper. Analyze the effect it had on his drawings.

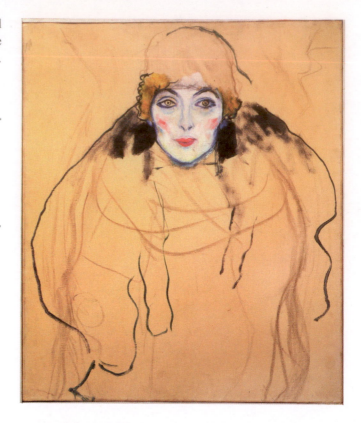

Figure 8.11
This artist rendered his image using colored media on a colored ground. GUSTAVE KLIMT, *Female head*, 1917/18. 26 × 22 inches. Lentos Museum, Linz, Austria.

Glue a piece of craft paper or grocery bag on this page and experiment with color media on colored ground.

COLOR FOR EMPHASIS AND EXPRESSION

DEFINITION: Emphasis in a drawing is the use of a visual device that draws the attention of the viewer to one or more focal points.

In Figure 8.12, the artist used color to emphasize the focal point, which is the green pencil. The taped pencil is an example of "trompe l'oeil" (fool the eye), as it seems to be three-dimensional and not part of the drawing.

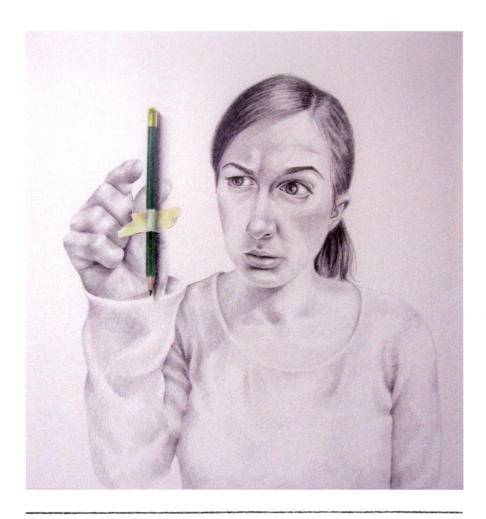

Figure 8.12
By using color only on the pencil and tape, the artist ensured that we would notice it. JENNY HARMS, *Inspiration is Elusive,* 2007. Graphite and color pencil on paper, 13 × 12.5 inches. Student work.

Do some graphite pencil sketches below, and add color selectively to them.

Figure 8.13 is a pastel drawing in which color is used for both emphasis and expression. The color is overstated and not naturalistic, which highlights the artist's feeling of a scream passing through nature. What emotions do you associate with Figure 8.14?

F.Y.I.
Research Helen Frankenthaler and her contemporaries who used color and gesture expressively in abstract expressionist paintings and drawings.

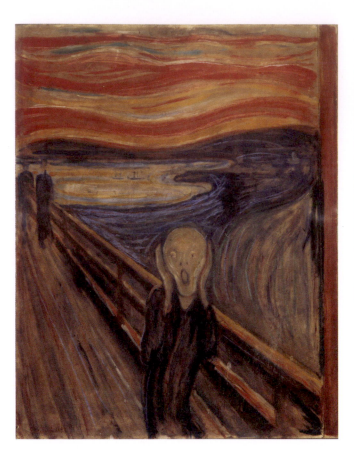

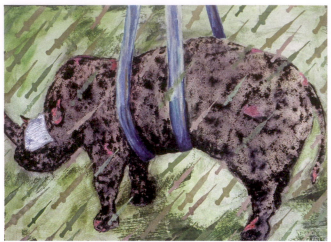

Figure 8.14
Analyze this drawing. Consider how the color and imagery work together. What do you think is the meaning of this image? LAUREN EVANS, *Flood*, 2002. Mixed media drawing, 22 ½ × 30 inches.

Figure 8.13
Color used for expression. EDVARD MUNCH, *The Scream*, 1893. Pastel, 36 × 28 inches. National Gallery, Oslo, Norway.

From your own life, choose something, some person, or some situation that embodies a high degree of emotion for you. Draw boldly. Use color. Don't hold back.

MONOCHROME, LIMITED, AND FULL-COLOR DRAWINGS

Adding color to a drawing is an option and a choice. Adding color always adds complexity. When you decide to use color, be deliberate about your choices. A **palette** is the range of colors used in a particular artwork. It is often a subset of all the colors available to use (Figure 8.15). A **monochrome** palette is simply one color. Variety is added by applying different degrees of pressure. **Limited color palettes** use two or three colors. Figures 8.8, 8.9, 8.10, and 8.12 are all examples of limited color palette drawings. **Full color** drawings use the entire range of hues available in a medium, as already seen in Figures 8.1 and 8.13.

Figure 8.15
Monochrome (top), limited (middle), and full color (bottom) palettes.

A monochrome is a drawing made with a single color or hue. Figure 8.16 is a nearly monochromatic drawing done in two shades of red conté. The expressiveness of the red color is heightened by the vigorous hatching and reinforces the impassioned face.

Figure 8.16
This nearly monochrome drawing in intense reds conveys the strong emotion felt by the artist. AUTHOR WORK, *Scream,* 2005. Conté on paper, 30 × 40 inches.

Do two or three monochrome sketches here. For each, work with a color that adds to the meaning or emotional content of your subject.

A limited palette refers to the use of only a few colors in making a drawing. In Figure 8.17, the artist used black, gray, brown, and red for a complex, intricate effect.

F.Y.I.

Joseph Mallord William Turner created many landscape sketches with expressive use of color. They were works of art in their own right as well as studies for paintings. Contrast his sketches with his final paintings.

Figure 8.17
This is a limited palette drawing, with roots in low-saturated colors against a golden background. JAMIE SWEETMAN, *Golden Roots,* 2008. Mixed media on paper, 42 × 54 inches.

Experiment with monochrome and limited-palette sketches.

A full-color drawing uses the entire range of the color wheel. In Figure 8.18, the artist applied a yellow ground, which makes an effective foil for the black and blue lantern and its red shadow.

F.Y.I.

Look up the works of two contemporary artists, Jennifer Bartlett and Chuck Close, with highly personal use of color. Also, research Odilon Redon's full-color pastel sketches.

Figure 8.18
This is a full-color drawing, with the artist applying color to the support itself to create its color ground. AUTHOR WORK, *Running light*. 1974. Pastel and charcoal on craft paper, 12 × 12 inches.

Develop some full-color sketches. Try some against a white ground and others against a colored ground.

SYMBOLIC, DIAGRAMMATIC, OR ARBITRARY USE OF COLOR

Colors can be symbolic and associated with ideas or events. A flag's colors are tied to national identity and patriotism. Different colors can be associated with events, depending upon the culture, as white in Western weddings for purity or red in Asian weddings for fecundity and luck. One color may be associated with many, even contradictory ideas. For example, blue might mean ethereal purity or depression. Yellow can mean cowardice or caution (Figure 8.19).

Figure 8.19
Yellow has symbolic meaning in road signage, and in this drawing adds a warning of danger against the black background. DAVID LAYTON, *By So Bye,* 2010. Pastel on paper, 10 × 14 inches. Student work.

In some cases, the use of color may be diagrammatic, as in a map or illustration in which different colors are used for clarity or to distinguish one class of objects from another. In other cases, you may not understand the reasons for an artist's color choices just by looking, but you respond to the work viscerally (Figure 8.20).

Figure 8.20
This work is an example of color use that is not directly based on observation, but may be symbolic, diagrammatic, or arbitrary. ANN PAGE. *Motile Set,* 2008, Prismacolor pencil and pastel on Arches paper, 26.5 × 16 inches.

F.Y.I.

Investigate the use of color from other cultures. Medieval manuscript artists often drew with brilliantly colored inks in the sacred texts they illustrated. Their colors usually had symbolic references. Aboriginal artists of Australia used color in their diagrammatic drawings to create maps of the physical and spiritual terrain. Find other examples.

Start with a colored map as a background, and sketch on it using color symbolically or diagrammatically.

CRITICAL ANALYSIS

Choose two drawings by artists from the F.Y.I. boxes in this chapter. Print out a 2″ × 2″ copies of each, and glue them into the space below, adding the name of each artist.

1. **First Glance.**

 Drawing 1

 Drawing 2

2. **Describe how each artist uses color in their composition.**

 Drawing 1

 Drawing 2

3. **Compare the expressive qualities in each work.**

 Drawing 1

 Drawing 2

Set up a still life made up of only white, black, and grey objects (no color). Then render it using colored media. Apply the colors you feel intuitively as you observe the objects. Have fun with it!

THE CREATIVE PROCESS

ALL THINGS CONSIDERED: COMPOSITION

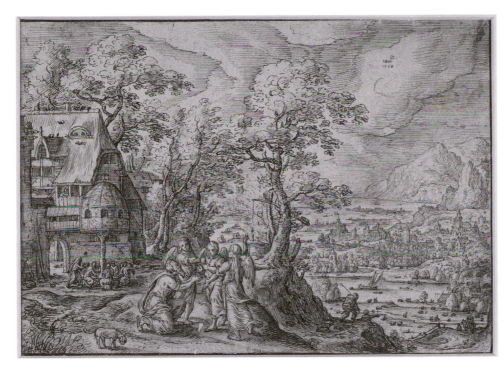

Figure 9.1
This is a complex drawing, in which the artist carefully organized the abundance of elements to achieve visual unity as well as variety. HANS BOL (1534–1593), *Abraham and the Three Angels*, 1568. Pen and brush with brown ink on paper, 8 ¼ × 11 ¾ inches. Museum der Bildenden Kuenste, Leipzig, Germany.

DEFINITIONS: Composition is the organization of the elements in an art work (see Chapters 3 through 8 for the elements). The **Principles of Composition** include **Balance, Rhythm, Proportion and Scale, Emphasis, and Variety**, which are thoughtfully combined to attain **Unity** in an artwork.

In Figure 9.1, the artist carefully and consciously considered all the Principles of Composition, as outlined below:

- Balance: The darker left side is balanced by the lighter right side.

- Rhythm: The horizontal lines of the landscape and the verticals of the trees, figures, and houses are repeated.
- Proportion and Scale: The size shifts between the huge house at left and the distant hamlet.
- Emphasis: The figures are at the center and are proportionally larger to stress their importance.
- Variety and Unity: There are thousands of individual marks and details, but all are rendered in ink with pen in a delicate, flowing, and integrated style.

This chapter covers the principles of composition in detail.

USING THE PRINCIPLES OF COMPOSITION IN YOUR DRAWING

Now that you have the foundations of drawing, you need to skillfully put them all together in a drawing, using the **Principles of Composition** (also called the **Principles of Design**).

All of these principles function on the picture plane of your drawing (also called the "page"), which frames your drawing. You are responsible for everything that happens there. You must choose what is in it, what is cropped out of it, what is in the center, and what is squeezed to the edge. The page edges establish horizontal and vertical directions, and everything inside is relative to them.

Using thumbnails, you can experiment with composition quickly before you commit to a large, detailed drawing.

In the space below, do several thumbnail sketches of details from Figure 9.1. Shift the elements around within your small frames. Crop and arrange the vignettes in different ways.

BALANCE

DEFINITION: Balance is the visual equilibrium in a composition, achieved by organizing the visual weight and significance of all the elements in an artwork. Balance can be **symmetrical**, **asymmetrical**, or **radial**.

With **symmetrical** balance, one side mirrors the other as if a line were drawn in the center of the composition (Fig. 9.2).

Figure 9.2
This composition shows symmetrical balance. AUTHOR WORK, Untitled. Colored pencil and tape, 18 × 24 inches.

Leaf through a magazine and cut out and paste below some images showing symmetrical balance.

With **asymmetrical** balance, dissimilar elements are arranged so they exist in groupings of equal visual weight and attention. The two hands mirror each other, but the henna imagery is assymetrical. Even so, the density, detail, and dark-to-light ratio is balanced in the imagery on both hands.

Figure 9.3
The two hands together form a composition, illustrating assymetrical balance. *Mehndi covering the hands.* Ludhiana, Punjab, India. Henna drawing.

Radial balance exists when repeated elements expand outward from a central point, as seen in Figure 9.4.

Figure 9.4
A radially balanced drawing loosely based on a design motif from Figure 9.3. CECELIA DAVIDSON, Untitled Design, 2013. Ink on paper, 5 × 5.5 inches.

In the space below, take some of your old doodles or make new ones, and create radially balanced drawings out of them.

Sketch details of buildings below that show symmetrical, asymmetrical, and radial balance.

RHYTHM

DEFINITIONS: Rhythm in a composition is the repetition of similar elements separated by intervals. The recurring elements move the viewer's eye through the composition, which creates unity.

Rhythms can be seen in textures, patterns, and shapes. In Figure 9.5, the placement the eyes, mouths, and noses create rhythmic repetitions on a large scale. On a smaller scale, the textures in the eyebrows and hair and the hatching in the background exhibit rhythm.

F.Y.I.

Rhythm and repetition were central in the artwork of Russian Constructivists and Italian Futurists, as well as abstract painters such as Anni Albers, Robert and Sonia Delaunay, Paul Klee, Victor Vasarely, Bridget Riley, Georgia O'Keeffe, and Jackson Pollack. Pick two and compare and contrast their work.

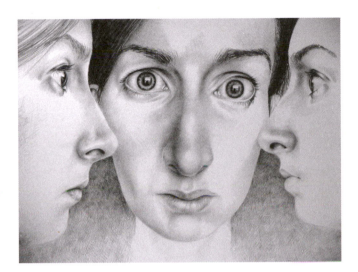

Figure 9.5
The eyes, noses and mouths are rhythmic elements in this work. JENNY HARMS, *Decisions*, 2007. Graphite on paper, 12.5 × 13 inches. Student work.

Pick one artist from the F.Y.I. box on the previous page and do some sketches inspired by their work, emphasizing rhythm and repetition.

Regular rhythm is systematic: a visual element appears repeatedly with the same interval in between. In **alternating** rhythm, two or more elements are interchanged and repeated, producing a predictable sequence. **Eccentric** rhythm can seem pattern-like, but the elements and spacing have surprising or subtle changes. Find examples of each in Figure 9.6.

F.Y.I.

Look at the modernist drawings from 1900 to 1920 for examples of rhythmic repetition.

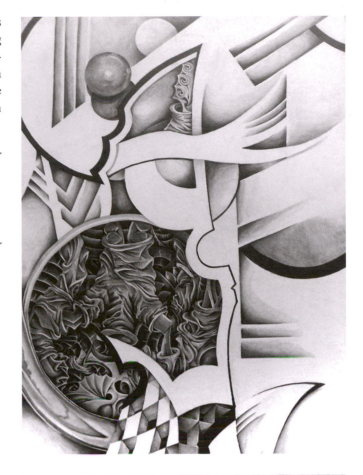

Figure 9.6
This work contains a rich assortment of regular, alternating, and eccentric rhythms. STEPHEN TAYLOR, *Cubist*, 2010. Graphite on board, 30 × 20 inches. Student work.

Listen to examples of three dissimilar genres of music. Make three unique abstract patterns based on the rhythms in each.

SCALE AND PROPORTION

Scale is the apparent size of an object or image compared to the human figure or to other familiar things. The large scale of the buildings in Figure 9.7 is clear because the closest structures do not even fit on the page but spill off the top and sides of the drawing. The stone walls dramatically overshadow the people who occupy only the bottom third of the drawing.

F.Y.I.

Rhythm and repetition were central in the artwork of Russian Constructivists and Italian Futurists, as well as abstract painters such as Robert and Sonia Delaunay, Paul Klee, Victor Vasarely, Bridget Riley, and Jackson Pollack.

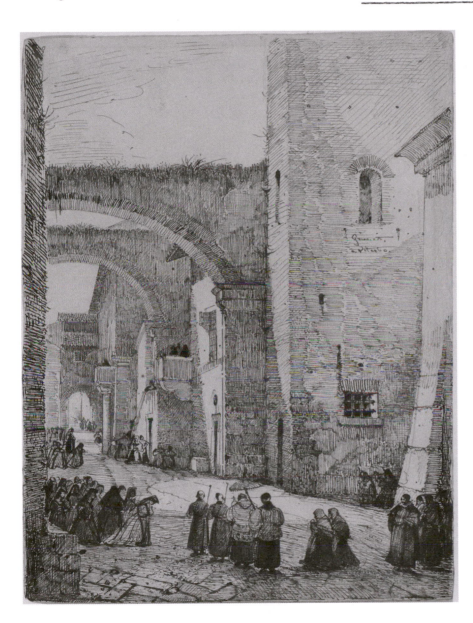

Figure 9.7
This drawing emphasizes the scale of the buildings in relation to the scale of the people on the street. FRANCOIS-MARIUS GRANET, *A Priest Processing through a Medieval Street in Viterbo*. Pen and brown ink over graphite on wove paper, 11 × 8 inches. National Gallery of Art.

Proportion refers to the size of one element in relation to other elements in an artwork or in relation to the whole page. In Figure 9.8, the oversized tire tread enhances the illusion that you are very close to this bike and makes it look monumentally large.

For both scale and proportion, the placement of your image on the page is important. The thin sliver of a building in the far left of Figure 9.7 goes almost from the bottom to the top of the page. The bike in Figure 9.8 spills off of all sides off the page, making the bike seem larger and more dramatic.

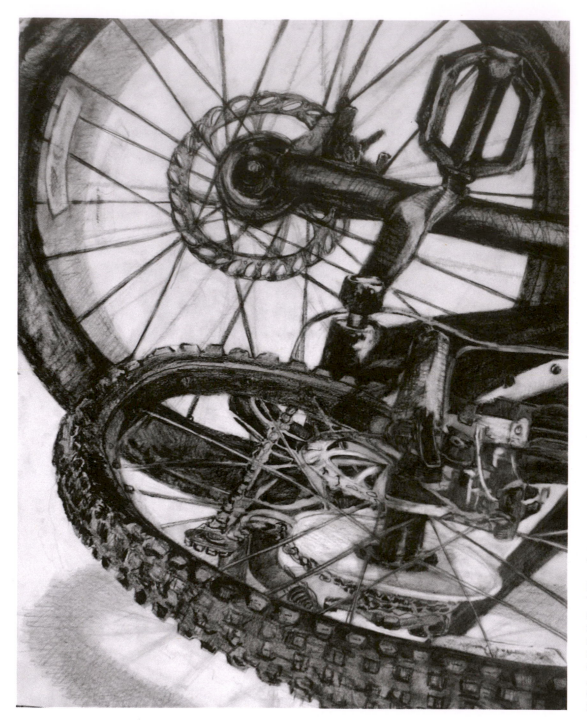

Figure 9.8
This artist uses scale and proportion to make the bike seem monumental. RICHELLE GRIBBLE, *Bicycle Study*, 2009. Graphite on paper, 20 × 16 inches.

Take something tiny. Sketch it and make it appear large.

Take something huge and make it appear tiny in a sketch.

EMPHASIS, VARIETY, AND UNITY

Emphasis is a device in art that draws the attention of the viewer to one or more focal points in an artwork.

Variety refers to opposing or contrasting visual elements that add interest in a composition.

Figure 9.9 shows how the principle of **emphasis** bolsters the psychological concept behind the drawing. The white front of the building is dramatically emphasized against the dark, brooding sky and gray surroundings. This is important because the artist highlighted the 1950s nightclub entrance and then added the faces, truck, legs, and guitar to describe what he imagined might have been the many histories of the building. Figure 9.9 also shows **variety**. Some areas are rendered with expansive black tones, while others are linear and precise. The variety adds interest and intrigue; it also adds to the notion of multiple histories.

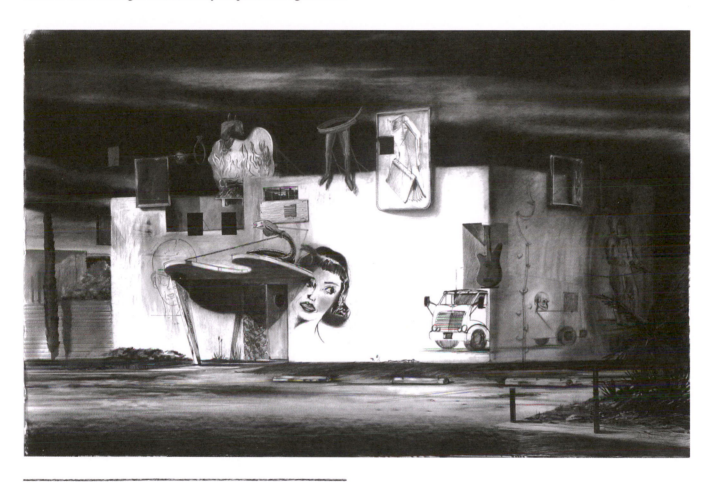

Figure 9.9
In this composition, the artist emphasized the front of the building and used various drawing styles for expressive purposes. BOB ALDERETTE, *D.O.B; Color; Use; Location*, 1998. Charcoal on paper, 29 × 41 inches.

Draw something simple in your environment, such as a chair, table, or bed. Using your imagination, overlap it with other images of what might have happened in the past or could happen in the future. Use a different media for each overlaid image. Decide what is critically important in the picture, and emphasize it.

Unity is derived from the harmonious use of all the elements in an artwork (Figure 9.10).

Figure 9.10
Consistent marks and a sense of deserted space unify this work.
AUTHOR WORK, *Sun Walk*. From the ancient ruins of Teotihuacan, Mexico, 1985. Ebony pencil, 40 × 26 inches. Author's collection.

CRITICAL ANALYSIS

Select one drawing from two different artists. One should be filled with great variety or feel like it is about to fly apart. The other should feel very orderly and contained. Again, print a small image of each and paste here.

1. Analyze each drawing and describe how the artists used the Principles of Composition to create these different effects:

Balance

Rhythm

Proportion and scale

Emphasis

Variety

Unity

2. Which artist comes closest to your personal style? In what ways?

With all things considered, Go for it!!

DEVELOPING PERSONAL EXPRESSION

Figure 10.1
This artist is known for his distinct style that explores an individual's mental state. FRANCES BACON, *Self-Portrait*, 1976. Oil and pastel on paper mounted on canvas. Musee Cantini, Marseille, France.

All artists want to develop their own ideas and individual art styles that are unique and distinct (Figure 10.1). This chapter discusses individual art styles, and three extended exercises are provided to help you foster this development.

DEVELOPING YOUR PERSONAL EXPRESSION

DEFINITION: Your choice of subject matter, the media you use, and marks you make enable you to express your thoughts, emotions, and ideas. This is your personal **visual vocabulary**.

Artists throughout history have developed their own personal styles and expression while reflecting their times. For example, Michelangelo had a lifelong fascination with drawing muscular bodies, and he developed his own unique style of representing them (Figure 10.2). But his art also reflects Renaissance humanism. For Claude Monet, his theme was water lilies, but the interest in the outdoors echoes the ideas of Impressionism.

You must undertake a journey of growing from a student who completes assignments into a creative person who generates ideas from your imagination and from your culture (Figure 10.3). As your ideas grow, you will find new and unique ways to express your personal vision (Figure 10.4). An individual's mark making in drawing can be compared to an individual's hand writing in a manuscript, that is, no two are alike! Your subject matter also becomes your own. You may be drawing apples and vases now to complete exercises for developing skills. In the future, you will draw apples only if you choose to do so.

F.Y.I.

Artists as diverse as contemporary anime artists, action hero comic book artists, and historic artists (such as Vincent van Gogh and Pablo Picasso) are known for their distinct individual styles that also reflect their time period. Find some examples of styles that you think are very contemporary, and contrast them with historical examples.

Figure 10.2
Michelangelo drew the human body in a heroic and idealized way. MICHELANGELO, *Studies for the Libian Sybil*, 1508–1512. Conte chalk on paper, 11 3/8 × 8 7/16 inches.

Make a list below of ideas, themes, or images that interest you. List the artists who draw these themes.

Figure 10.3
These composite human-insect characters are examples of work that reflects the artist's ideas and the animation culture. FELICITY GUAN, *Insect Series: Worm, Centipede, and Walking Stick*, 2012. Ink on paper, 18 × 24.5 inches each. Student Work.

In the space below, consider one of your themes and represent it in three different drawings.

An artist's personal visual vocabulary is a unique combination of subject matter, media, and marks made, but it can also include the size of the work and where it is installed. In Figure 10.4, the artist cut random pre-printed T-shirts into thin strips to create dark lines, mounting them on a white wall. She also sewed on them, creating a large drawing of flying dead birds that addresses human consumption and pollution that affects the sea. This drawing installation was displayed in a gallery in a California coastal city; where it was installed added to the meaning of the work. The large size emphasizes the global problem of trash in the ocean.

F.Y.I.

Many artists make drawings from unusual materials like Edith Abeyta's T-shirts. Cai Guo-Qiang makes drawings from gunpowder and fireworks. Tibetan monks make sand drawings. Native Americans make drawings from dust, pollen, sand, chalk, and powdered charcoal.

Figure 10.4
The artist used unique materials and scale to create a powerful, personal statement against pollution. EDITH ABEYTA, *T-Shirt Doodle with Pelican Skeletons*, 2012. T-shirts cut in strips and pieces, interfacing, thread, sewn stitches, and nails, 8 × 24 inches (entire installation and detail).

Make a list of all the materials you can think of that could create a line in a drawing. Think of everything from embroidery to skywriting to squirting catsup out of a bottle. What ideas or themes might be associated with each of those media?

THE HABIT OF SKETCHING

Start sketching all the time. This is a great way to develop your ideas and your drawing skills. You can carry a tiny sketchbook, no bigger than your cell phone, which becomes your personal visual diary (Figure 10.5). Or draw on anything that is available (Figure 10.6). Gather those sketches and keep them someplace where you can see them. This practice will help you get better at nailing the essence of an idea or a scene. Later, the sketches will help you remember your thoughts and experiences at a particular time and place.

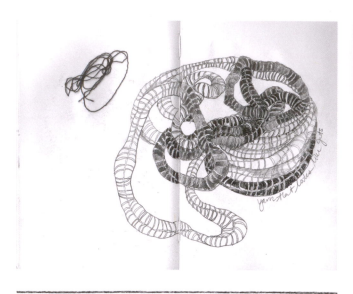

Figure 10.5
A small sketchbook with a drawing inspired by a scrap of yarn, plus a note that says the yarn drawing looks like guts. ELIZABETH ARZANI, *Yarn that looks like guts*, 2012. Graphite, pen and thread on paper, 8 ¼ × 10 ¼ inches. Student work.

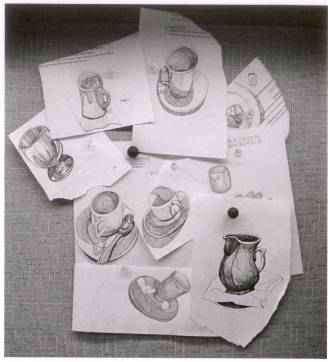

Figure 10.6
This shows several drawings of teacups on napkins and hotel stationery, done by one artist who has sat through many, many meetings. SUSAN METROS, *Tea Cups*, 2011–2012. Pen on paper scraps, various sizes.

Over the course of the next day, take this sketchbook everywhere and draw. Note the date, time, and place of each sketch.

Continue your visual diary here. Note the date, time, and place of each sketch.

THREE PROJECTS TO DEVELOP PERSONAL VISION

The rest of this chapter will be focused around three exercises that will help you develop your personal expression and vision (no apples or vases unless you are really passionate about them). When you do these exercises, work from sketches done from observation or your imagination. You can also selectively use photo references, for example, to help with details where needed. However, your work should not copy a single photo source, which is restrictive and stunts both your imagination and observational skills. Here are the projects:

1. The self-portrait project
2. The series project
3. The narrative project

1. The Self-Portrait Project

The self-portrait project is an opportunity to focus on distinctive marks and how they can be used for personal expression. Self-portraits are both an external and internal self-image. The choice of media and the variety of marks are the major means of conveying the internal likeness. Figures 10.7, 10.8, and 10.9 are all self-portraits, one from each of the authors. Also, look again at the self-portrait in Figure 10.1.

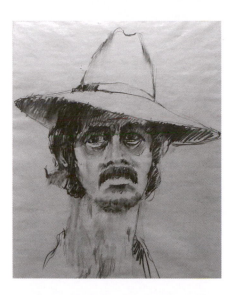

Figure 10.7
AUTHOR WORK, *Self-Portrait in a Hat*, 1971. Charcoal on paper.

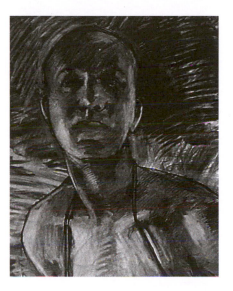

Figure 10.8
AUTHOR WORK, *Self-Portrait after Chemo. (detail)*, 2004. Charcoal on paper. Original drawing, 45 × 60 inches.

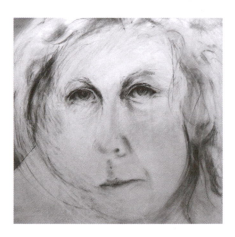

Figure 10.9
AUTHOR WORK, *Self-Portrait*. Pencil, pastel, and eraser on paper.

In the space below, analyze and make notes about the characteristic of the mark in each self-portrait, as well as for Figure 10.1, the self-portrait by Francis Bacon.

What kinds of marks and media would you use for your self-portrait? The rough dark tones of charcoal, the quick gesture of pastel, or the expressive use of pencil and eraser? Figure 10.13 shows other choices as well.

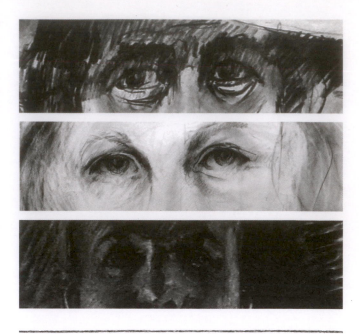

Figure 10.10
Three self-portrait detail images compare rendering styles and use of different media.

Find one self-portrait by two of these artists: Rembrandt van Rijn, Albrecht Durer, Frida Kahlo, Egon Schiele, Kathe Kollwitz, Vincent Van Gogh, or Chuck Close. Sketch a detail of each below, imitating the style. Analyze the marks and make notes. What does the medium contribute?

Figure 10.11
This is an example of the split self-portrait.
CELINA FRELINGHUYSEN, Untitled,
2012. Pencil on paper, 15 ½ × 24 inches.
Student work.

Sketch your own portrait using a mirror (do not use a photograph). Divide your face in half, as you see in Figure 10.11. On one side draw your physical reality, and on the other side your emotional self. Use different media for each side. Analyze your own mark-making style in notes below your sketch.

Take 10 photo self-portraits. Choose three that portray some aspect of yourself. Take details from each one and combine them into a single portrait drawing that is a truer representation of yourself than a single photo can give.

2. The Series Project

Making a series of drawings on one subject matter is a great way to develop your personal expression. Choose a subject that you care about and that interests you. For example, the artist Georgia O'Keeffe was fascinated by close-up views of organic, curving forms, and she produced great artworks of shells, bones, and enlarged flowers (Figure 10.12).

Figure 10.12
This artist devoted much of her creative work to depicting close-ups of organic, curving forms. GEORGIA O'KEEFE, *Snail*, 1920. Charcoal drawing. © The Georgia O'Keefe Foundation.

Figure 10.13 shows three watercolor sketches of fountains, which were part of a large series of fountain drawings. In each, the watercolor was allowed to puddle up, so that when dry the sketch still showed the traces of the liquid watercolor. Combining that technique with atmospheric perspective resulted in fountain sketches that seem ethereal, misty, and more dream-like than solid.

Figure 10.13
The artist worked with wash media in order to add meaning to the idea of fountains and fluidity, and also to unify all the drawings in this series. AUTHORS WORK, *Three Drawings from the Fountain Series (Bethesda, Turtle, and Maritime)*, 2001. Watercolor on paper. Each drawing 22 × 15 inches.

Make several sketches over the next few pages of a particular subject that interests you.

Continue sketches of a theme or idea of your choice. Try different media. Which media do you think works best for developing your idea?

Continue sketches in your series.

Figure 10.14 shows two drawings in a series that examines new ways to playfully approach drawing the human body.

Figure 10.14
This artist focused on details of the human form, and uses heavy lines to emphasize shapes. CARMEN NEELY, *Give and Take* (left) and *Those Legs* (right). Both are charcoal, pen, pastel, acrylic on paper, 23 × 21 inches. Student work.

Continue sketches in your series.

3. The Narrative Project

Narrative is another possible means of developing your personal expression in drawing. Narrative drawing explains an act or transition that happens in time and space. Narrative drawings can combine many scenes into one image, they can tell a story in stop-action, or they can be a smooth 30-frames-per-second animation. You can show every detail, or you can depict a few key scenes and count on the viewer's mind to fill in the blanks. Consider using symbols that can efficiently provide the back story to your tale.

Figure 10.15 tells the story of wine making in ancient Egypt by combining several steps into one scene: picking grapes, mashing them, collecting the juice into a vat, and eventually filling the large jars with wine.

Figure 10.15
A story told by combining several scenes in one drawing. *Men picking grapes and making wine.* Detail of a wall painting in the tomb of Nakht, scribe and priest under Pharaoh Tuthmosis IV (18th Dynasty, 16th–14th BCE).Tomb of Nakht, Sheikh Abd el-Qurna, Tombs of the Nobles, Thebes, Egypt.

Write down some notes about possible stories to explore.

Your narrative can be a grand event or a very modest narrative, such as a cupcake being eaten (Figure 10.16).

F.Y.I.

Some of the many examples of narrative drawing are seen in artist books, which range from medieval manuscripts, Aztec folded books, or books by contemporary artists such as Kiki Smith. Also, Francisco Goya, William Hogarth, and William Blake did series of drawings which told stories. Research these works to see how the narrative unfolds in each.

Figure 10.16
The disappearing cupcake. LENNA NGUYEN, *Confectionary Consumption*, 2012. Graphite on sketch paper, 24 × 18 inches. Student work.

Select a story to explore. Choose a subject matter, media, and style of drawing. Should it be shown in one scene or many? Start mapping out a narrative in thumbnail sketches.

Figure 10.17 shows various strategies for narrative in drawing. The top shows voice balloons that tell a story. The middle is like a storyboard in TV screens that tell a story about watching TV. The bottom uses graphics that communicate emotions. Notice also the use of collaged elements, cartoon-like drawings, and photographic likenesses.

Figure 10.17
These three narrative drawings are from a series of 24 that deal with growing up in a Chinese-American household. SANDRA LOW, *Ma Stories*, 2004–present. Mixed media and sizes.

Sketch your narrative drawings.

Continue your narrative sketches.

CRITICAL ANALYSIS

Select two series of drawings by a historical artist, an animation artist, a comic book artist, or a contemporary artist who created a book. Describe them below.

1. **First Glance.**

 Series 1

 Series 2

2. **Analyze mark making**

 Series 1

 Series 2

3. **Analyze the element of narrative, if it exists.**

 Series 1

 Series 2

4. **Which appeals more to you, and why?**

CRITIQUE

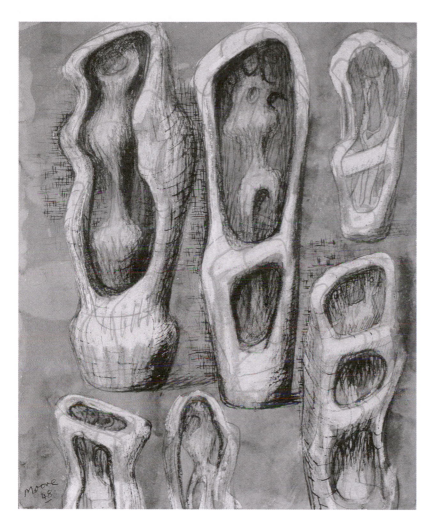

Figure 11.1
This artist used several sketches to critically analyze his ideas for a series of sculptures. This kind of self-critique is an ongoing process for artists. HENRY MOORE, *Image from Sketchbook 1947/48: Ideas for Upright Internal/External Forms,* 1948. Pen, ink, watercolor, and crayon on paper. Private Collection, London, UK © Henry Moore Foundation.

DEFINITION: A **critique** is a systematic and thorough analysis of all aspects of a drawing to evaluate whether they work together to create an effective result.

If you practice analyzing your drawings and the drawings of others, you are practicing critiquing skills, which will help you improve your drawing.

Criticism and critique are not the same. Criticism has negative connotations of disapproval. It is a judgment of good or bad. Critique is different because it is analysis and a process for learning and affirmation. In Figure 11.1, the various sketches allowed the artist to compare one possibility with another.

This chapter discusses methods of critique and self-critique and offers you ways to challenge yourself to make better drawings, now and in the future, including:

1. Using the sketchbook to develop ideas and retain the original spark
2. Gaining inspiration
3. Seeing with a fresh eye
4. Receiving feedback

USING YOUR SKETCHBOOK TO DEVELOP IDEAS AND RETAIN THE ORIGINAL SPARK

When planning a major drawing (versus a casual sketch), work out your ideas in your sketchbook. Use thumbnails to decide your composition, point of view, and elements to emphasize. Try lots of variations. Also, write notes to yourself to capture key points and important qualities.

Review your notes and thumbnails as you are drawing, as a benchmark to keep you focused.

Figure 11.2, 11.3, and 11.4 shows sketches an artist made when developing an idea for a sculpture composed of paper airplanes printed with headlines of the Iraq war. This is how an idea evolves from a sketch to an installation in a gallery. The artist first decided the overall shape for the work and then designed a wire suspension system for the airplanes. Figure 11.5 shows the final piece, *Descent*.

Figure 11.3
In another sketch, the artist shows that she wants the planes to form a large sweeping shape. JOYCE DALLAL, 2007. Pencil in sketchbook, 2 × 5 inches.

Figure 11.2
This is the artist's sketchbook pages showing the plan for paper airplanes, icluding a few ways that they might be stacked and suspended on wires. JOYCE DALLAL, sketchbook page with plans for *Descent*, 2007. Ballpoint pen, 5 × 7 inches.

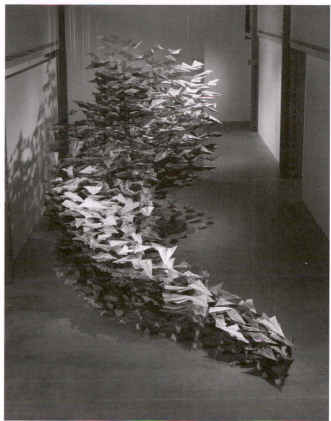

Figure 11.4
Sketch showing the plan for the overall shape of the installation.
JOYCE DALLAL, 2008. Pencil, 8.5 × 11 inches.

Figure 11.5
The final work installed. JOYCE DALLAL, *Descent*, 2008. Japanese paper, steel cables, concrete, 36 × 15 × 8 inches. Photo credit: Susan Einstein.

Make a list of topics that would interest you for a big drawing, a series of drawings, or a drawing installation. On the next two pages, experiment with different ways to approach the drawing(s). Think it through in sketches, thumbnails, and notes.

On this page and the next, plan a drawing based on one of your topics of interest. Experiment with six thumbnail compositions. Collect photos to help you with details. Do preliminary sketches from observation. Finally, analyze your sketches and source material. Which expresses your idea best?

Continue sketches from the previous page.

INSPIRATION

Looking at drawings of other artists can help you enormously as you develop your ideas and your style. Here are some suggestions:

1. Look at the works of other artists dealing with your same subject matter, one that you like and one that you don't. Write an analysis of their drawings.

Use the space below for your analyses.

2. Compare the work of several artists you like. What is their subject matter? How do they use the elements and principles? What does this reveal about your own tastes and priorities?

3. Do the same comparisons with artists you dislike. Deciding what you don't like is also deciding what you do like.

SEEING WITH A FRESH EYE

The longer you work on a single drawing, the harder it becomes to see it as others see it. The methods below will help you evaluate your drawing while you are in the process of making it.

1. ***Step way back from your drawing:*** Looking at your work at a distance is the best way to check:
 - The proportions of the objects and the figures you are drawing
 - The entire composition (is it effective?)
 - The overall contrast of the drawing (do you need more lights and darks?)
2. ***Turn the drawing upside down:*** This is a very good way to evaluate the composition.

3. ***Look at the drawing in a mirror:*** This flips the image, which is again helpful for the reasons already stated.
4. ***Put the drawing away and don't look at it for a few days:*** When you take it out again, often you know exactly what you have to do to finish the drawing and to take it from "pretty good" to "great."
5. ***Look at a photo of your drawing:*** Study what your drawing looks like when you see it on your camera or cell-phone screen. The change in media and scale helps you see it differently.

 Check back with your original notes and thumbnails while you are looking at your drawing in new ways. Make changes that emphasize and bring out your idea and intention.

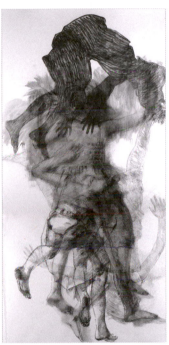

The drawing as the artist planeed it.

What it looks like, updisde down.

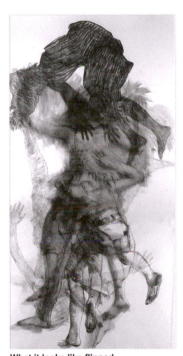

What it looks like flipped.

Figure 11.6
When you see your drawing in new ways, you can ask yourself questions like: Should the figures be clearer or fuzzier? Is the composition effective? Is a background needed or not? How well does one part flow to another? AUTHOR WORK, *Tumbling Julia*, 2003. Charcoal and conté on paper, 92 × 45 inches.

What it looks like at a distance or through a camera.

In Figure 11.6, the artist wanted to make a drawing about a child's tumultuous process of growing up. As you critique the various views of this drawing, what do you think of the works given the intention of the artist? What would you recommend changing? Write or draw your responses below.

FEEDBACK

Ask other people what they think of your drawing.

Ask average people without art training for their opinion to find out what the work looks like to the general public. Don't pay too much attention if they critique certain details or if they ding you for not being sufficiently realistic when you intend to do an abstract work. The value of their feedback may be limited, but it can be helpful to know what the "person on the street" thinks about your work.

Equally importantly, ask people with trained eyes, such as other artists, critics, or designers to look at your work with you. They can help you rigorously analyze your work, and they can give you very valuable advice on all aspects from technical issues to detail issues to the large picture.

Join an artist group to have a regular circle of people who see your work develop and help you with the long-term trajectory of your work.

Always remember to take from critiques only that which will help you grow.

Make a list below of good people to ask for feedback on your work. Choose only those who will be genuinely helpful.

CRITIQUE GUIDES

This section contains two different guides to use to critique artworks. The first is for a self-critique, to help you analyze your ambitious drawing projects as they are in process, and once they are finished. The second is for critiquing the works of other artists.

Self-Critique

This comprehensive self-critique guide draws on all the points that we have covered so far. While it is designed for self-critique, this process can also be the basis of critical conversations you have with your friends about their work.

This guide works for ambitious drawings, not for 10-minute sketches. To use this guide, you must plan and execute a large, ambitious drawing, one that might take you several hours or even days to complete. Because of the time investment, the subject should be important to you.

Follow this process for the planning and execution of your drawing:

Step 1. Preparation

- Look through your own sketchbook to find the topics that are compelling to you. Look at your thumbnails and sketches. Make a list of ideas.
- Write down your first thoughts. Then develop your ideas, expand on them, select the ones on which you want to focus, and expand those again.
- Identify key ideas.
- Do research. Accumulate source material.
- Look at other artists for inspiration.

- Make thumbnails.
- *Keep these materials to review again once your drawing is complete.*

Step 2. Experiment

- Media: Having experimented throughout this book with different kinds of media, choose two or three that resonate with your subject and style for this involved drawing. Try a few sketches of the same subject with each.
- Elements (line, value, shape and volume, space, texture, and color): For your particular drawing right now, what should be emphasized? What should be avoided? Try a few sketches.
- Composition: Try out some alternatives with thumbnail sketches.
- *Keep these sketches to review again once your drawing is complete.*

Step 3. Document Your Process

- Take at least six to eight photos of your drawing, about an hour apart, as it develops. Keep them nearby for reference.
- Do the "Seeing with a Fresh Eye" exercises.
- As the drawing progresses, get feedback from artists and friends. Make notes of their comments.
- *Keep these photos and notes to review again once your drawing is complete.*

Once you have completed these steps and your drawing is finished, you are ready to analyze and evaluate your results. Use the guide on the next page to complete this step.

OPTIONAL: Make a short, 5-minute presentation of your drawing to others, showing the final work and also how it developed through research, experimentation, and execution. Allow at least 15 minutes afterward for feedback and discussion.

Self-Critique Guide

- Review your notes, ideas, thumbnails, sketches, research, experiments with media, and experiments with composition and elements.
- Review the photos that documented your process and the comments you received.
- Have your finished drawing in front of you.

Formal Analysis: Analyze and describe the composition and your use of the elements (review Chapters 3–9).

Effectiveness of Media: In the end, was your media choice the best for this work and its subject?

Original Intent: Did you realize the results that you wanted when you were preparing and researching this drawing. If the results were different, where were the key decision points? When did major changes emerge?

As you review the entire project, were there other possible outcomes or interesting alternatives that could be pursued in other drawings?

Possible Directions for the Next Drawing

What works successfully? What could be improved?

Meaning (What ideas and emotions ultimately come through from the subject and the execution of the drawing?

Below is the Critique Guide for analyzing works by other artists. Make several copies of it, and use it to help you really get to know the works of artists you admire. As you engage in sustained viewing of these works, you will discover more than you will with a quick overview.

Critique Sheet for Analyzing Works by Other Artists

Artist's Name:

Title, Date, Size, and Media of Drawing:

First Glance (jot down short phrases with your first impressions):

Extended Analysis:

Subject Matter (Check the title. Is the work representational or abstract, what do you see in the work?):

Media (Describe and identify the materials used. Check the caption, if available.):

Elements (Identify and describe the use of each; review Chapters 3–8):

- Line
- Value
- Texture
- Shape and Volume
- Space
- Color

Composition (Describe how the elements are arranged, use of space, areas emphasized, and if balance, rhythm, unity and variety are evident):

Meaning (How do all elements, plus your interpretation, convey meaning in this work? Compare with your first impressions):

INDEX